To Margaret

A Romance with Steam

A Romance with Steam

by
Chris Woods

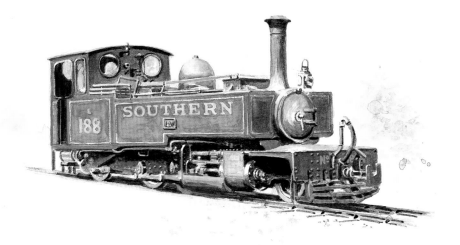

Published by
Waterfront Publications
463 Ashley Road, Parkstone, Poole, Dorset BH14 0AX

In Association With Nicholas Smith International Limited

© Chris Woods & Waterfront Publications
ISBN 0 946184 77 1
1993

British Library Cataloguing-in-Publication Data.
A catalogue record for this book is available
from the British Library.

Typesetting and layout by
The Madhouse, Ringwood, Hampshire.

Printed in England

Contents

Author's Appreciation6

A Reflection7

Introduction8

The Painting Excursion......13

Guinevere at Cheesehill16

Along the Camel18

Drifting Through Devon20

Up to Ais Gill22

Standing at Looe24

West Country Express26

Watching28

Crossing of the Ways......30

The Hayling Billy32

The Silver Jubilee34

Once Upon a Time......36

Cambrian Way38

Wintry Morning......40

City of Lancaster42

Arrival at Droxford44

Summer Saturday46

The Travellers......48

A Moment at Sherborne50

Waterloo52

Three Ladies at Salisbury54

The Bournemouth Belle56

The Secret58

Bodmin at Ropley60

The Cunarder62

A Winter's Tale64

The Viaduct66

The Trainspotters68

Time for Thought70

Waiting at Botley72

Evening at the Shed74

Lion76

Duty at Folkestone78

Over the Canal80

Sunday at Salisbury82

Change at Axminster84

Each a Glimpse86

Island Holiday88

Eclipse of a Star90

Winter Freight92

Epilogue94

Acknowledgements95

Lee-on-the-Solent96

Author's Appreciation

Photograph by John Whisson

Since becoming a painter, the vast majority of my work has been to commission and, therefore, from the work available, I have made an honest attempt to put together an amalgam of anecdotes and colour plates, which I hope will provide at least a modicum of interest for the reader. Should your favourite locomotive fail to reveal itself within these pages, I am truly sorry. It is certainly not by design!

In anyone's success I believe that luck plays its part. I have been lucky! I have been privileged to meet many fine, empathetic folk from varied walks of life. They have been kind, considerate and have gone out of their way to be helpful to me in my work. At the drop of a hat they would engross themselves in research by frequenting the libraries, to plough through relevant volumes on the trail of some elusive vital fact; or providing reference material from their own private collections. All of this for my singular benefit! It is here then that I extend my thanks to them all, especially my friends John Hill, Duncan Swift, Pursey Short and Mervyn Turvey, each of whom has constantly responded to my habitual appeals for assistance.

I must make a special mention now of my dear old Mum, whose enduring faith in my ability is something that maybe only she could see. She has always been there when my need has been greatest, and even today willingly functions 'behind the scenes' in any way she can.

I thank also my friend and publisher, Roger Hardingham, for his belief in my work and my questionable ability to meet the deadline.

Finally, I extend my heartfelt thanks to my wife, Margaret. When I have been painting she has had to tolerate the occasional grunt as a substitute for reasonable conversation, which must be exasperating to say the least. She has been the driving force and support behind any success I may have achieved, and no superlatives of mine can possibly be adequate in an attempt to indicate my gratitude to her. But for Margaret's encouragement and foresight, this book would be a mere figment of the imagination.

Yes, I have been *very* lucky!

A Reflection

(Extract from a letter dated 11th November, 1990)

. . . We had a lovely journey down to Plymouth, the S.R. and G.W.R. trains were bang on time and the service was first class.

The weather was fine and sunny for the whole journey, and the countryside looked lovely from the train window. It made one feel it was good to be in England.

We had an excellent meal on board the Cornish Riviera; five shillings it cost – very good value.

I had a chat with the driver before we left Paddington, a King class locomotive was in charge, No. 6015 *King Richard III*. She was gleaming absolutely immaculately.

While I am on the subject of locomotives, I read in the railway press that Gresley of the L.N.E.R. has produced a real winner in the A4 *Silver Link*, and the 'Silver Jubilee Express'. Certainly shows a clean pair of heels to all the other express trains in the country. I hope to take a trip on it maybe next year.

The weather has been lovely these last two days at Plymouth; yesterday we saw H.M.S. *Rodney* coming into Plymouth, with R.A.F. flying boats flying overhead. One of them was a product of Supermarine Woolston Works.

The hotel is very nice and the food and service are excellent . . .

JOHN HILL

Introduction

Isuppose it would be true to say that my romance with steam locomotives and railway issues began when I was about seven or eight years old. I was born and brought up in Winchester, Hampshire, and in 1939 my parents took a house in Cheesehill Street where my father would be next to his place of employment as a baker and confectioner. My new home was adjacent to the Winchester Cheesehill Station and the top of our garden overlooked the goods yard, sidings and signal box.

We lived in that house for about eight years and during that time I spent many happy hours in that signal box where the signalman, Mr. Tyrell, had taken me under his wing. He allowed me to 'help' him pull the levers, using the inevitable duster to protect the shining handles. I was also frequently to be found on the goods loading platform where I talked to the driver and fireman of the shunting engine, and I remember them sharing their lunch with me – bread and cheese with a raw onion and tea to drink which was their staple daily fodder.

On one occasion I can recall cutting my finger with a penknife belonging to the driver. There was a craze at the time of making whistle-pipes from the hollow stem of hogweed. I needed the knife to cut the holes along the length of the stem from which to make the various notes when blown. The driver had warned me that his knife was indeed very sharp but as I have said I managed to cut my finger. The driver took me across the tracks to the fire bucket which was positioned at the foot of the steps leading up to the signal box. He took my hand and swished my bleeding finger around and around in the water and then escorted me up the steps to Mr. Tyrell who promptly found a bandage or plaster from the first-aid box and bound my finger up nicely and then sent me on my way. I bear the scar to this day! Isn't it odd how the apparently trivial and insignificant things remain somewhere within the labyrinth of one's memory, on stand-by for immediate resurrection.

In my boyish way these men became my 'friends' as they shared their day to day railway lives with me. An enduring love affair with steam railways had been conceived.

The years that I lived in Cheesehill Street coincided with those of the Second World War. I was too young to comprehend the utter odiousness of war; to me 'war' seemed to be the sole topic of conversation among adults when they met. What does remain with me, impinged on my memory, is the sight of countless hospital trains continuously arriving at the station. From my viewpoint at the top of the garden I could see large red crosses painted on the roofs of the carriages. They were bringing back wounded soldiers, sailors and airmen from the front to be disbursed to various hospitals within the area. I remember the walking wounded wore bright blue uniforms, white shirts and red ties.

My parents eventually moved in about 1947 to another house which, curiously enough, was not too far from the Southern Railway station which was served by the main Waterloo-Southampton-Bournemouth line. This station was known as Winchester City, thus avoiding confusion with Winchester Cheesehill which formed part of the Southampton-Newbury-Didcot railway catered for by the G.W.R. Today, since the closure of the latter to all traffic in April 1966, it is now known merely as Winchester.

My route to school now took me by the railway station and over the first of three road bridges situated on the south side of the station. After lunch I had a two-fold incentive to leave home early and hurry back to school. If I played my cards right I would not only be in time to see the down Bournemouth Belle, but also earn myself a

generous helping of pudding, saved for me by the school dinner ladies, in return for a regular wiping-up service at the kitchen sink before the afternoon session began. They breed them wily in these parts.

From my vantage point on the bridge I could watch the Bournemouth Belle approaching from some way off, a thrilling sight to behold. As the train raced towards me the Merchant Navy class engine would sway quite violently and dramatically from side to side as she hurtled the train through the station to disappear beneath my feet, enveloping me in smoke.

Smoke from the Bournemouth Belle for some inexplicable reason represented a curious significance for us gullible young spotters. Effectively, if one was 'lucky' to be caught in the smoke emanating from the Bournemouth Belle it induced some peculiar psychological advantage over one's fellow spotter; a sort of oneupmanship and something to brag about. What outlandish nonsense encumbered the minds of the impressionable young nippers of the day!

I would not in any way consider myself a railway fanatic – a bias towards the discerning would probably be an incontestable description.

I have indulged in more than my fair share of the youthful venture of train spotting in my time. I have also suffered the indignity of being shouted at and ejected from the running sheds at Eastleigh on more than one occasion, with the Shed Foreman in hot pursuit, his boot a bit too close for comfort, and "Don't let me catch you 'ere again" or "Let that be a lesson to you!" ringing in my ears. I suspect that ordinarily this admonishment would probably have had its desired effect in most situations, but the Eastleigh sheds definitely had a certain magnetism and intrigue like nothing I had encountered hitherto, which was bad news for the foreman's blood pressure. And so I ventured back there again and again, always keeping a constant eye out for the man wearing a trilby hat and long raincoat, the scourge of all trainspotters. However, the majority of visits were totally 'successful' in this respect, and the sheds being a perpetual source of new names and numbers for one's collection. The King Arthur class held a particular fascination for me as I was enchanted (and still am) by the mystical names of Arthurian legend; Sir Cador of Cornwall, Sir Blamor de Ganis, Sir Agravaine, Sir Sagramore, Sir Brian, Maid of Astolat, Camelot, Sir Urre of the Mount. I could go on. There were seventy-four in total in the class and I was able to gaze upon many of these alluring nameplates at Eastleigh as if, maybe, under Merlin's spell.

It was during this period of my life that I developed an aptitude for drawing and painting. It was recognised by the headmaster at my school who 'volunteered' me to climb up a ladder and paint a relevant inscription in Gothic lettering on the wall at the back of the class. Graffiti was a word not yet in general use!

The head was evidently pleased with my effort because he arranged for me to have day release classes at Winchester School of Art, the notion being that my future should be aimed in an artistic direction.

I recall that this period at art school was not at all as I had anticipated. My tutor was convinced that the artistic horizons of the whole class should be restricted within the confines of four objects. He persistently requested us to draw or paint a box, or an orange, or an egg, or his favourite, a vase; though not necessarily in that order! Sometimes we were told to illustrate these same objects as a group which he explained was known as still life. Wonderful! No, I

found it so deadly dull and boring, so much so that I found myself being rapidly overtaken by the fearful realisation that maybe a serious mistake had been made in my choice of career.

Nevertheless, I do remember on one occasion arriving for another monotonous roundelay of boxes, oranges and eggs, when I was greeted by a wild buzz of anticipation as I entered the hall. There was a strong rumour afoot that we were going to a life class. When the rumour had been authenticated there was an instantaneous lifting of a veil of apathy which hung over the majority of us, I fancy. Goodness me! We were going to a life class! On entering the classroom imagine my astonishment when I quickly realised that the reclining nude before me was a woman who lived in the same road as myself. I was gripped with apprehension as I wondered if she would recognise me during the period of the class. However, my inclination was to think not, but I was never absolutely convinced. One thing I do know for sure is that I looked upon her in an entirely different light from then on!

About this time I suffered a temporary mild aberration when my interests turned to draughtsmanship. Could I obtain a job in the drawing office at the Vickers Armstrong Aircraft Factory? My name was added to a long waiting list with a view to becoming an apprentice.

I was sixteen now and had left school and was temporarily engaged in the headmaster's office doing menial and abject tasks whilst patiently awaiting my chance to design the next star attraction at the Farnborough Air Show! It never came. Deplorably, jobs were as few and far between then as they are today and so, having served my sentence of six months in the school office, which seemed an eternity, in sheer desperation I grabbed the opportunity of an apprenticeship with a local printing company.

I remember quite vividly my interview with the company's managing director. He was most emphatic that my artistic bent would prove to be a mighty asset to my career in print. Naivety was in total command at this time as I hung on to his every word. How thrilled I was to learn from him that my earlier desire for a job with an artistic connection could be in some way fulfilled after all.

However, after only a few weeks the dire truth began to dawn on me – I was not going to derive any artistic pleasure, as I knew it, in any shape or form. My fears were corroborated in no uncertain terms by the 'wise men' with whom I worked. After only half a step out into the wide world, had I already been confronted by my first hoodwinker? Worse still, I had become ensnared in a six-year apprenticeship indenture!

Except for occasional furtive glances into my box of water colours all inclinations towards painting were now to become dormant, stashed away in a cocoon – maybe for ever.

Continuing circumstances were to compel me to persevere within my so-called 'chosen profession' and so, in consequence the next thirty-four years of my life were to be concerned with printing and publishing, and to find me deposited in diverse parts of the country, embracing Hampshire, Cambridge, Dorset and Cornwall in that sequence.

Whilst living in Cornwall I became aware that railway artist Don Breckon was living about half-an-hour's drive from me and, after some preliminary correspondence, we met at his home one Sunday morning. I had long since been an admirer of his work and therefore was delighted to actually make his aquaintance and have the opportunity of seeing many of his paintings grow from blank canvas into classic Don Breckon railway scenes.

I discovered that I was becoming steadily influenced by him in two ways: he was rekindling my love of steam locomotives, and I was also conscious that the spirit of my latent artistic ability was being stimulated although I am sure he was not aware of any of this at the time. It was a joy to watch him at work in his studio and I learnt such a

great deal through chatting with him and observation and duly attempted to load as much as I was able of the newly-acquired know-how into the memory bank.

I spent many happy times in the company of Don and his wife, Meg, swapping anecdotes and experiences, and generally dunking ourselves in nostalgia. I remember those days with affection and, unwittingly, when my future was predestined.

In October 1982 I was overtaken by a period of utter devastation. My dear wife, June, was taken suddenly ill and rushed to hospital in Truro. After undergoing two emergency operations she lingered for a time on a ventilator, but sadly she failed to recover and passed away a few days later.

Suddenly my world had collapsed around me, the blow having driven me into a state of suspended animation. It was some time before I was able to concentrate on the day to day involvements, though I had already returned to my desk at the printing company in Padstow. In the meantime my mother, to whom I owe debts of gratitude of mammoth proportions, had travelled down from Winchester to take on the task of housekeeper.

Life could never be quite the same again, but time was passing and by now we were into 1983. It was April and spring was in full flight; the countryside was looking green and new and fresh from winter slumbers; the sun's rays were upon everything, thus enabling me to begin to see matters in a different light, and to assist me in coming to terms with my situation.

Then it happened. Another crisis. Redundancy! I felt as if I'd been pole-axed at the time and curiously the only thought racing through my head was how I was going to tell Mum and what her reaction would be. On reaching home I broached the subject straight away.

"Mum, I have some bad news, I have been made redundant. I have joined the ranks of the unemployed!" To my astonishment she made no fuss and showed no glimmer of despair.

"Never mind, boy, when one door closes another one will open", she replied.

I shall never forget that moment. A strange calmness ensued as a result of her words and the trauma of the moment evaporated. From that moment on I began to see much more clearly what lay ahead. The shackles of my life in print had been thrown off. The opportunity to paint presented itself. It was staring me in the face. It had been a very long wait indeed! I was now fifty!

My immediate priority was to find an adequate space in which to paint and leave everything *in situ* when finished for the day, thus avoiding the frustration of constant packing-up of materials and unpacking it all again the next day. It was simple; the answer was upstairs.

I utilised a spare bedroom as a makeshift studio, and in it set up a large drawing board, propped up on an old drop-leaf dining room table as a base. You should have seen it! If I had tuition at the Heath Robinson College of Further Education I would unquestionably fail the exams.

I began to build up quite a stock of art materials and railway reference books, which I was able to acquire by means of frequent forays on appropriate shops in Truro. Now followed a lengthy period of study, self-teaching and continuous practice. It was a hard slog but I was determined to succeed. There was no way in which I was going to squander my one chance to be a painter. The die had been cast.

Nine months had drifted by, during which time I managed to sell several paintings in a local gallery. This was very encouraging. However, I had taken the decision to sell my house in Cornwall and move back to my 'home' county . . . I'm a Hampshire Hog! My reason for my return was that happily I was to marry again.

Margaret had been a life-long friend of my late wife, June; they had both been nurses at the Royal Hampshire County Hospital in Winchester during their younger days. Margaret was a Community Midwife based in Titchfield and we married there in June 1984. She has been my constant source of motivation and has supported me in every way, ready to give my confidence a boost if she noticed the first signs of it flagging.

I began painting on a full-time basis about twelve months later, setting myself a target of seven years in which to become a success; if this failed I would have to find myself another job. Thankfully I have been fortunate!

It was about this time that BBC Radio Solent heard of me. They were preparing a new series of programmes to be broadcast on Thursday mornings. The presenter Dennis Skillicorn visited me, complete with his recording paraphernalia and, after a few attempts, a satisfactory account of my experiences was achieved. The concept was to select certain individuals from the local radio area, for whom life, for one reason or another, had taken an entirely different tack from that which had gone before. Hence the programme title 'Change of Direction', a logical heading but a generalisation, and as far as I was concerned somewhat of an understatement. I believe that I experienced more than a mere change of direction; I had been through a transition from type-setting manager to railway artist and consequently my life today is vastly different. I call it metamorphosis!

I am ever mindful of all the friends I have been fortunate to make since venturing forth on this chapter of creation and contentment in my life. Not only have they been a faithful source of information; many times, and uncomplainingly, at their own expense, but also for just being there, providing opportunity to relive and exchange wonderful memories of people and things, or places and happenings, during the quieter moments of our lives. Should they choose to read these words, they will know who they are.

It is these quieter moments of which I write when I relax and allow my mind to drift back and recall with gratitude, as I attempt to disentangle that which has occurred over the past ten years or so. Of one thing I am certain; it is a culmination of these recollections which has enabled me to resume, and continue my romance with steam locomotives, recreating on canvas the memories I have of the days of steam all that time before.

The Painting Excursion

Painting plays a multifarious role in my life. It provides me with stimulation and excitement to achievement and self-satisfaction. It contributes to the pleasure of others, which I hope is not too extravagant a claim, but necessarily remains of vital importance to me. Also, of course, it does provide me with a source of income. However, before any of these disciplines can be realised, the germ of an idea for a painting has to be uncovered. These ideas can spring from any direction, often from the simple or unlikely source; browsing through pictorial reference books, spotting something in the wayside whilst driving through the countryside, or out walking the dogs or even sat idly watching television.

Artists tend to scavange ideas from place to place, collating them together to file them away into a kind of library of personal tastes one might say. Many of my ideas stem from the countryside, things of nature. I am strongly influenced by the countryside and all that goes on under its umbrella, I always have been. I can recall a temporary phase during my teens of having delusions of grandeur in wanting to be a zoologist and naturalist. I even wrote to David Attenborough for advice. His reply was very informative and polite, but left me in no doubt that I really should concentrate on art!

I may be somewhere, anywhere, when the outline of a tree or copse will catch my eye simply because of its shape, which for me must convey a feeling of softness as well as purpose. Anything and everything has to be considered; simple things like pastoral openland with a meandering stream trickling by to disappear from view as it finds its way under a tumbledown wooden bridge and beyond. Long abandoned farm machinery hiding away among the nettles and other undergrowth make fascinating shapes to include in paintings.

When I have an inkling for a painting busting to see daylight I begin to surround myself with masses of reference material concerning the subject in question. I generally spend about a week to ten days, maybe more, researching the issue and gathering together and checking the facts. One has to be constantly aware of dates, location changes over the years, and particularly any idiosyncracies regarding the class of locomotive to be represented, such as modifications to certain numbers within the class and when they had taken place.

The time spent on research, together with sound planning and preparation is crucial to effect total authenticity. I go to great lengths to obtain the facts for the painting in every respect if at all possible. Because of this I will not enter beyond the bounds of possibility or even, if I can help it, probability. I relate an example of what I mean. A

man rang me one day to enquire if I would be prepared to paint his favourite locomotive hauling the Golden Arrow. I expressed a keen interest in the project and enquired if he knew whether the locomotive had in fact ever hauled this celebrated train. He assured me that it must have done, which by implication meant that he wasn't sure! "Have you a particular location in mind?", I asked. Imagine my surprise when he replied, "Yes. I would like it passing Sutton Bingham Reservoir". For those who might not be aware of its geographic whereabouts, Sutton Bingham Reservoir is just south of Yeovil in Somerset!

When I explained to him that I would not be able to do that because the Golden Arrow ran from Victoria to Dover, he became quite aggresive and told me that he wished he had not bothered to ask me; that my services would not after all be required and that he would seek out another artist who *would* be prepared to oblige him. I often wonder if he was successful! So you see what I mean by 'beyond the bounds of possibility'!

When the research is complete, sketches or working drawings are done, when ideas are played around with, altered and adjusted, until an acceptable result is achieved. When everything has been checked out again, the painting can begin. The main features from the sketch or drawing are transferred onto the canvas in a very basic fashion. Now it is time to squeeze out onto the palette the range of colours I use. It is at this moment that should there be any 'stardust sprinkled' inspiration going begging then I'm its man! The problem is if it's not it is simply not possible to hang around peering at a blank canvas or gazing into space awaiting the so-called devine influence to manifest itself. The waiting time can amount to plenty and, in consequence, a distinct lack of productivity ensues. One cannot affort to wait!

Artists work differently having their own approach to their painting. Some give the fresh new canvas a coating of a brown underpaint. This gets rid of the glaring white surface and may create a psychological advantage in knowing that it is no longer 'blank'. Others cover the canvas with appropriate colour and tone, crudely painting in the various main features of the picture which is called 'blocking in'. My way is to start with the locomotive, usually with the chimney, painting in the dark tones first and 'drawing' the main shapes and lines of the locomotive with the brush at the same time. I constantly paint as the mood takes me, working from one area to another and back again. If I find myself in what I can only describe as a 'fiddly' frame of mind, then I will work on the locomotive or anything in the picture confined within precise guidelines until I feel the need to relax more, in which case I will then attack the surrounding landscape. This procedure continues until the canvas is covered and the painting begins to show signs of coming together. I continue to set aside 'detail days' when I spend quite a number of hours 'building' the locomotive, making adjustments here and there where necessary.

A painting on average covers a period of between four to five weeks, sometimes longer, depending very much on the size of canvas chosen and the subject matter portrayed. It is now that I leave the canvas on the easel to be the focus of my attention for some time, seeking out the need for any minor adjustments which might possibly enhance the overall appearance – or maybe not. Accentuating certain highlights with a mere touch of the brush can make a vast improvement, surprisingly.

There comes the time when I seem to be looking for something to dab at or tittivate and it's now that I deem the painting to be finished. I believe that knowing when to stop is one of the more crucial aspects of painting as it can be frighteningly easy to fall victim to the overkill syndrome!

The painting remains on the easel for some days inviting comment from Margaret or friends who look in from

time to time. I favour their deliberations and appreciate constructive criticism. Naturally a new painting tends also to lay one open to friendly banter and flippancy! I can relate a wonderfully amusing example of what I mean. For those who remember the well-loved Tony Hancock and warmed to his comic genius on the black and white 'steam' telly, may recall one episode entitled 'The Artist'. Tony portrayed the artist dressed in true Rembrandt tradition, wearing the heavy smock, floppy flat velvet hat, set off by a large cravat tied at his throat. He was busy at the easel when his housekeeper, Mrs. Cravat, entered the studio. She peered over his shoulder and gazed at the painting in progress. "What is it?", she asked. "It's a self-portrait", answered Tony, tetchily. "Who of?", enquired Mrs. Cravat, quizzically. "Laurel and Hardy!", came back the exasperated reply.

As I have intimated earlier my way of painting is not the way of all artists. But it works for me. Some artists work very long hours, fourteen or fifteen hours every day! This indicates to me that they have to be strict disciplinarians, notwithstanding the fact that little time remains for anything else.

A disciplinarian I am not! Some days I may start about 8.30 a.m. and work through until about 6.00 p.m. (this occurs when the level of inspiration is high and the painting is really flowing); other days not quite so many hours. Though I love my work, like anyone else going about their daily form of 'breadwinning', some days one feels like it and other days, well . . .

I have no inclination whatsoever in the direction of engineering. I even tend to find DIY baffling to a degree! Because of this incompetence it would indeed be an extravagance to declare any certain knowledge of the internal workings of the railway locomotive. Funny, really, being able to paint the subjects I do so many folk see me as an engineer. I have overheard conversations whilst at exhibitions of my work: "Oh, yes. To be able to paint that sort of thing he's got to be an engineer". I can assure you that I am not. As far as I am aware it is purely the aesthetic value of the steam locomotive which attracts me like iron filings to a magnet.

Suffice to say it is not merely 'steam' that nudges my adrenalin. No matter how hard I try, I just can't seem to get enthusiastic about traction engines, steam rollers, steam driven lawnmowers, and the like. Obviously they all have their place in the world and have a following of thousands of folk, and rightly so; but it's just not my 'line', though I must say I seem to have developed a guilt complex about it. So for me the attraction is not steam alone, it is the steam locomotive.

I am a romantic, constantly striving to create a sense of nostalgia and wellbeing in all my paintings, whether they be of railway subjects, or whether they be of aeroplanes or boats which, incidentally, provides welcome diversification from time to time.

Somewhat naturally, I suppose, I become attached to the majority of the paintings and, in consequence, sorry to see them disappear through the door when the time arrives for them to go out into the world. Nevertheless I can glean a feeling of warmth in the knowledge that as the new owner gazes on the latest acquisition from the comfort of an armchair, his or her memory bank will slip nonchalantly into overdrive and the pleasant moments of the past will be reflected upon and relived again . . . and again . . . and again . . .

Guinevere at Cheesehill

G.W.R. Duke class locomotive No. 3256 Guinevere *rolls gently into Winchester (Cheesehill) Station with a three-coach train bound for Southampton Terminus about 1935.* Guinevere *was built in 1895 and withdrawn from service in 1939, still carrying its red painted lamps (which the Great Western Railway changed to white after 1936). 30 x 20 in. 1990.*

One occasion found me unexpectedly reunited with someone whom I had not seen or heard of since our days at school. He had seen my work whilst on a visit to a local gallery and, not knowing who I was, had asked the owner of the gallery how he could get in touch with me with a view to a commission. Telephone calls ensued and during the conversation we realised that we knew each other from those far-off days in Winchester. He, like myself, had lived at one time within a stone's throw of Winchester Cheesehill station. He desperately wanted me to paint him an original and was prepared to leave the subject to me. I enjoy commissions like this because it allows me complete freedom to express myself more fully and the painting tends to flow.

In view of the circumstances the choice of subject was simple!

I decided that the station should be portrayed in a period setting because in my opinion Cheesehill exuded atmosphere. It continued to maintain its charm until the day of its closure in 1966; even the advent of British Railways failed to disturb the ambience of the Didcot, Newbury and Southampton Railway!

However, one change that British Railways did bring about was to alter the spelling of the station name from Cheesehill to Chesil, a simple corruption. It came into use in 1950.

In common with many cases throughout the country, standing on this site today is a multi-storey car park, though mercifully, in this instance, of reasonably sympathetic design.

The painting brought back many happy memories for Peter Brokenshire, its new owner, as naturally it did for me.

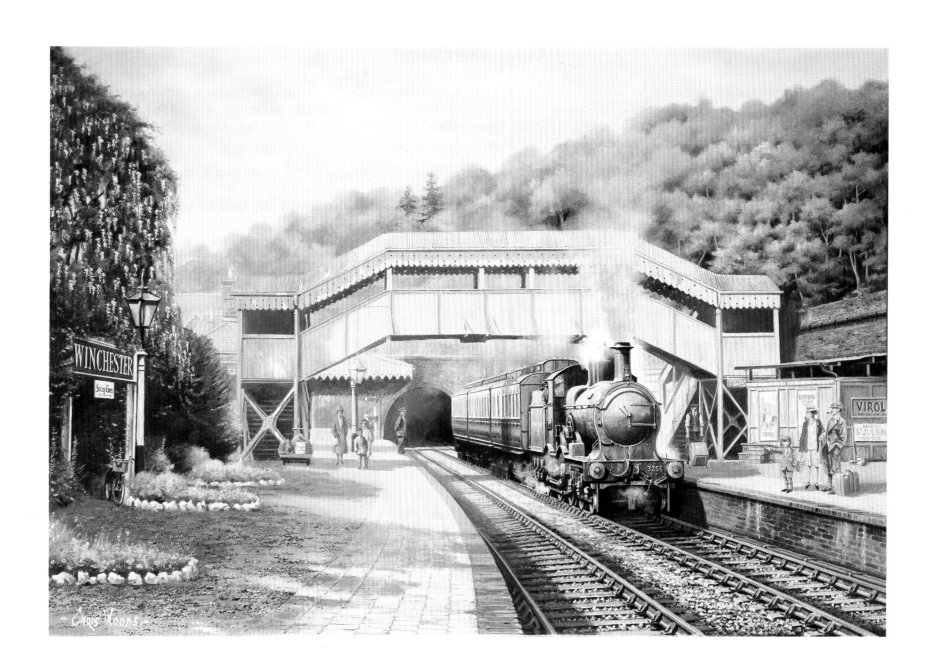

Along the Camel

Drummond T9 class 4-4-0 No. 30120 is seen bringing the Okehampton two-coach train into Padstow with only about 100 yards to go before reaching the station and the end of the line. This locomotive was built in 1899 and withdrawn in 1963. It was loaned by the National Railway Museum to the Urie S15 Preservation Group who restored it to working order for service on the Mid-Hants Railway, but has subsequently moved to the Swanage Railway. 30 x 20 in. 1985.

At times I feel quite despondent. Because of 'progress', many of the things we all loved and hankered for are lost forever. It was this maudlin thinking which inspired 'Along the Camel'.

It seems to be a phenomenon of human nature to constantly reflect on what used to be, and we tend to live in our own subconscious world of comparisons.

"It wasn't like this in the old days!" How often have you heard that said down the years – folk philosophising over the pros and cons of progress in general.

Today, I fancy transportation bears the brunt of our 'progress' grievances.

One is constantly aware of the continuous programme of building new roads; motorways marching ever onward, devouring our countryside like there is no tomorrow; scything through where swallows skimmed and harebells nodded from grassy banks.

At the same time I think that a tendency exists to lose sight of the decimation of the railway system, brought about by Beeching's hatchet squad, closely followed by the marauding mobsters who tore up track and demolished bridges at a stroke, changing the bus-less rural inhabitants' lives for ever. Interestingly though, paradoxically almost, nature has reclaimed a good many of these one-time branch lines by consuming them beneath a blanket of bracken and briar, thus giving us back in a way more actual 'countryside'.

Leisure trails and cycleways have been created from many other former track beds including that which runs alongside the immensely picturesque Camel Estuary between Padstow and Wadebridge, in Cornwall. It once formed the furthermost outpost of the Southern Railway, and this scene as such I chose to reinstate on canvas.

I know it well, and whilst wandering along towards the well-known iron bridge which spans Little Petherick Creek, I have sampled more than a few of Barnicutt's pasties in my time!

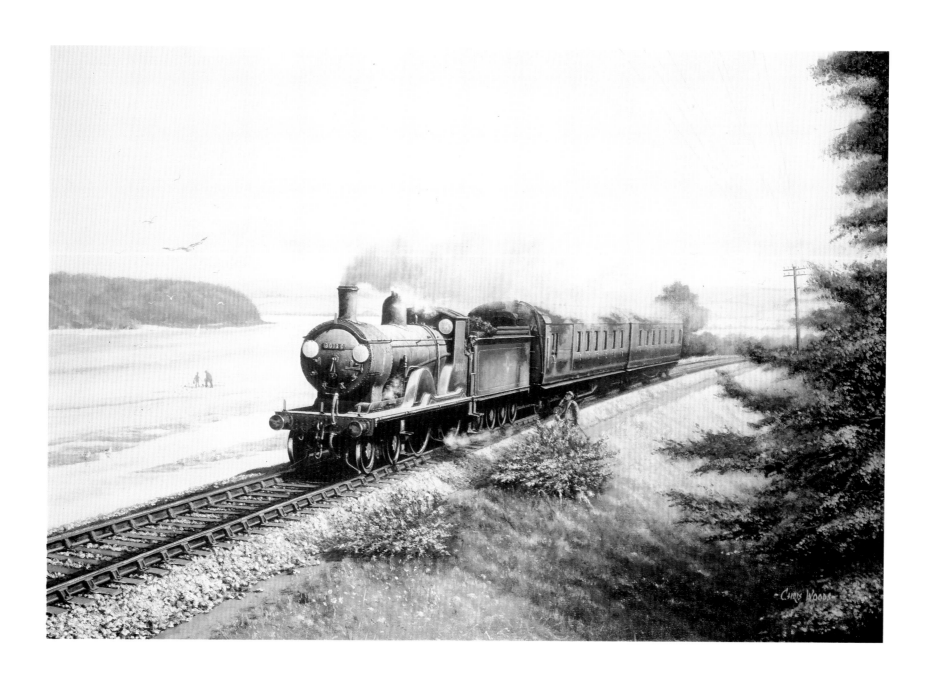

Drifting Through Devon

Ex S.R. Maunsell S15 class 4-6-0 No. 30847 drifts through Whimple Station with a train for Salisbury. This engine was introduced in 1936 and was the last in this class. It was withdrawn in January 1964. 24 x 18 in. 1988.

My brief was to paint an S15 with flat-sided tender, and to locate it somewhere west of Salisbury.

As far as the locomotive was concerned it was easy as I had ample reference material on this class. The choice of surroundings was not quite so simple. One is spoiled for choice really, but I fancied a country station. Whilst looking through many old photographs for inspiration I came across one of Whimple Station in Devon. I was particularly attracted to it by a tall monkey puzzle tree standing alongside the station buildings. Its shape was curious. It took the form of a pyramidal umbrella and it stood about thirty feet high, totally dominating the entire station.

The monkey puzzle or Chile pine (*Araucaria araucana*) comes from the hills and mountains of Chile and Argentina, and is surely the most improbable of all trees. Straight of bole and with rings of horizontal branches arranged with almost mathematical precision is its basic configuration. Its unique foliage is dark green, tough and leathery to the touch. These leaves are shield-shaped and spirally arranged like the scales of an armadillo except that they have a hard, sharp point. I would imagine that forests of these trees on the volcanic slopes of their Andean homeland look absolutely right, but isolated specimens like the one in question at Whimple, tend to look somewhat incongruous, but nevertheless interesting.

It was the notion of painting this tree which swung the location in Whimple's favour for 'Drifting Through Devon'. An unusual feature to be sure, it would effect added appeal.

When it comes to railway posters I am a pushover. I have an attachment for them. Whether the billboards advertise some particular enchanted liquid which claims to refresh parts that other enchanted liquid apparently cannot reach, or where one should transport one's family to by train for the annual seaside holiday or weekend break, it matters not as, in my opinion, they can all enhance the overall look of the station property and add to its character. So when painting a station scene I seldom miss the chance to include one or two, even if it should fall under the guise of artist's licence (as it applies in this instance).

Positioned on the end of the up platform, sheltering beneath the prickly canopy, was a slabbed concrete shed, secured by padlocked corrugated steel doors and furnished with a warning notice in red letters, 'DANGER – NO SMOKING'. I wonder as to the identity of the mysterious contents of that almost sinister-looking structure down there in deepest Devon! One's frivolous imagination can run amok. A mini nuclear reactor? A secret arms cache? Or perhaps a horde of sequestrated Devon Dumplings! Whatever was concealed within this fortification I somehow doubt it was anything more dubious than the station staff tea-making supplies! All totally innocuous. Although . . .

The porter glances wistfully across at the train as it coasts by. He has a crate, no doubt labelled for 'foreign parts' and will cross the track and strategically place it in position for loading aboard the next appropriate stopping train.

Incidentally, I understand, that at the time of writing, the *Araucaria araucana* is still in place and flourishing.

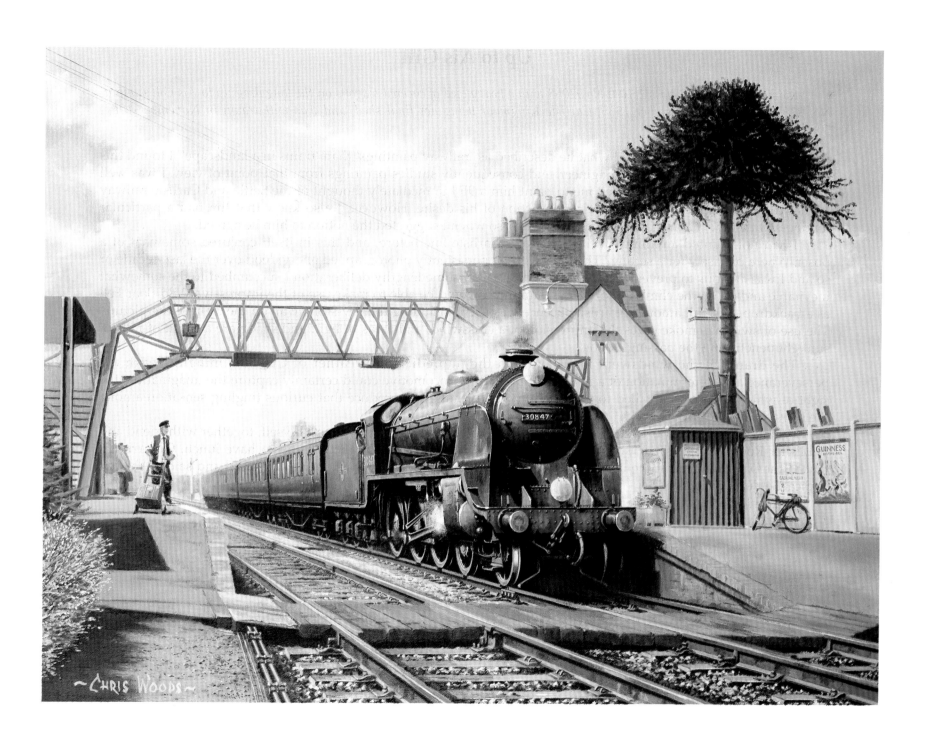

~Chris Woods~

Up to Ais Gill

Riddles Standard 9F class 2-10-0 No.92058 with a heavy load of covered wagons on the long drag up to Ais Gill summit. No. 92058 was built in October 1955, Carlisle Kingmoor being her final shed, and was withdrawn in November 1967. 30 x 20 in. 1990.

Jim Hodgson much preferred what he described as 'railway paintings' than 'trains in a landscape'. I found this quite understandable as Jim is an engineer, and consequently studies paintings from that point of view. I was well aware of this fact but when he asked me to paint him a 9F I immediately thought of the Settle and Carlisle railway for a location. This idea was in direct contradiction of his desire. However, I also knew that Jim had a particular fondness of the line, having travelled it many times, so when I suggested the notion to him he agreed.

I had not painted anything on the Settle and Carlisle line before, and this in itself conjured somewhat of a poser. Where precisely for a setting? The line has been persistently photographed and videoed over the last decade or so and I was anxious to prevent a stereotyped scene. After some lengthy deliberation I succumbed to the somewhat inevitable and chose the climb up to Ais Gill summit; I would be able to make use of the impressive Wild Boar Fell as a backdrop. A small amount of artistic licence was used, including the dry-stone wall on the right of the picture. The use of swirling smoke gives the impression of a crosswind, and areas of light and shade are a result of rays of sunlight penetrating the passing clouds.

The drama of the windswept moorland and the unpredictable weather of Cumbria mingling with the perseverance and determination of a powerful Standard 9F locomotive could certainly capture the imagination, the sight of which cannot have failed to thrill one, certainly enough to produce that curious tingling sensation among the hairs on the back of the neck!

When the painting was completed it was arranged that my wife Margaret and myself, together with friend and publisher Roger Hardingham, should drive down to Hove to deliver the picture and to have lunch. On arrival I placed the painting against the back of a chair for Jim's scrutiny. After a brief pause he smiled and said, "Ah, yes. Typical Settle and Carlisle!"

I was pleased and I believe Jim was suitably impressed. And the lunch was good as well!

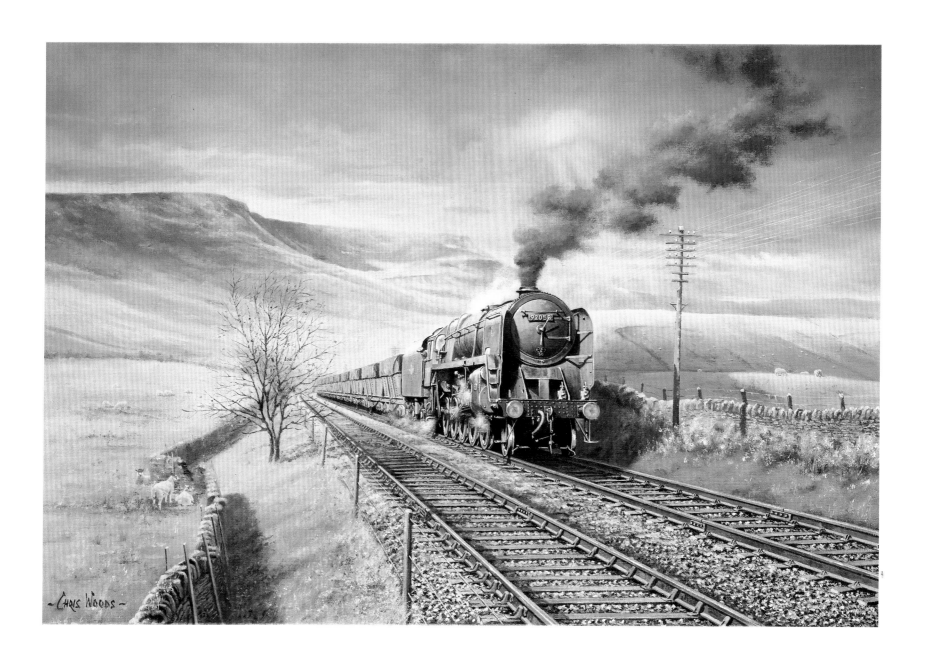

~CHRIS WOODS~

Standing at Looe

Ex G.W.R. Prairie Tank No. 4574 has just arrived at Looe Station with a two-coach train, possibly with holidaymakers from the big cities who would have changed at Liskeard for Looe. No. 4574 was built in 1924 and withdrawn from service in 1963.
24 x 18 in. 1991.

This is a favourite of mine and I deduce that the reason for this is two-fold. Firstly, I had been totally captivated by a painting of Looe Station painted by Don Breckon and shown to me by him in about 1981; and secondly, I had lived in Cornwall for about eight years and it is because of this I retain an instinctive fascination for that county of mystical charm. I am beguiled by the delightfully curious names of the quaint villages of picturesque geranium-potted cottages and guest houses.

One day in 1989 a letter dropped through my letterbox. It was from a member of the Art for Winchester 1993 Committee enquiring if I would be prepared to donate a painting towards the Art for Winchester Scheme to raise funds towards the preservation and improvements of the Cathedral and associated medieval buildings. The funds were to be raised by means of a London auction of paintings donated by about one hundred artists, to take place in 1993.

I was happy to assist the Art for Winchester 1993 Committee in their scheme particularly as I was a Wintonian. Among the ensuing correspondence was a list of the names of other artists who had pledged a painting; it made really impressive reading, and I felt a sense of pride in having been invited to add my name to such an exalted group.

As the paintings were received at the Art for Winchester 1993 office they were then dispatched to the art room at Winchester College for safe keeping prior to the auction in London.

This painting gave me immense pleasure, not only for the reasons I have outlined, but also because of romantic connotations. Looe was where Margaret and I spent our first holiday together. We took a cottage which overlooked the site of the old loop and sidings. It had been transformed into the inevitable car park, complete with health centre in this case. In earlier times the track continued beyond the bridge, which spanned the river connecting East and West Looe, to the wharves of the harbour.

The line continues today as far as the station itself, serviced by diesel multiple units which appeared on this branch in 1958-59, thus providing an important link to the main line at Liskeard for both local and holiday traffic.

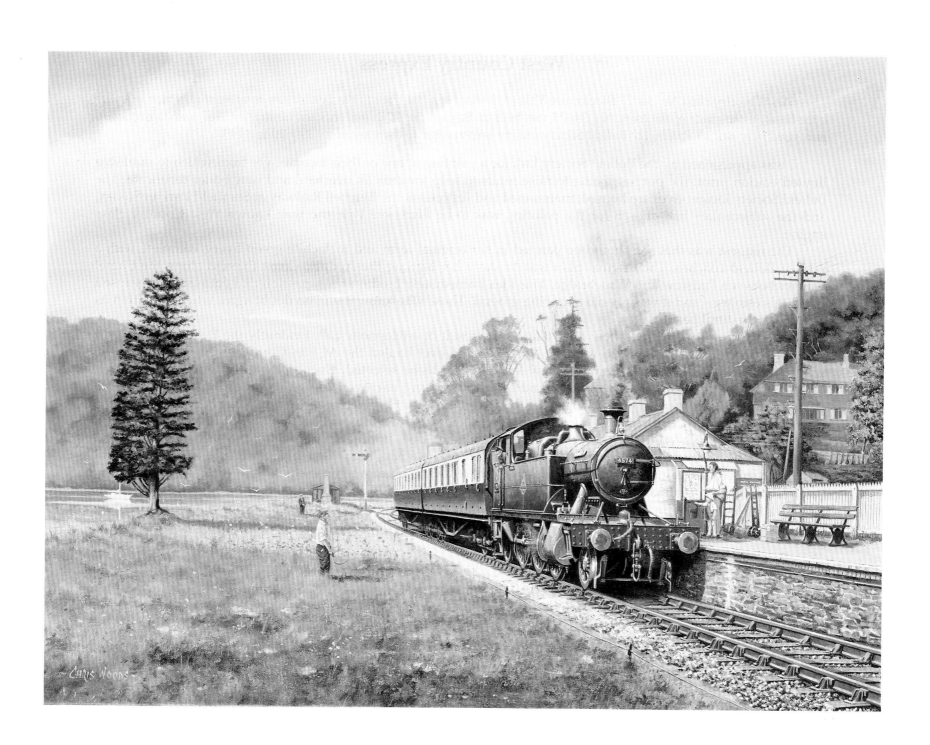

West Country Express

West Country class No. 34023 Blackmore Vale *at the head of a fast train to the west passes permanent way men enjoying a tea-break in the shade of the trees. No. 34023 was built at Brighton in 1946 and was withdrawn in 1967 and subsequently purchased from British Rail by the Bulleid Society Ltd. for preservation and safe keeping.* 30 x 20 in. 1990.

I was approached by the Bulleid Society Ltd. for a painting of one of their locomotives from which to publish a limited edition print, the purpose being to raise funds to help towards an overhaul and new boiler certificate. The Bulleid Society locomotives are housed, maintained and restored at the Bluebell Railway at Sheffield Park in Sussex, and the subject they had chosen for the painting was to be *Blackmore Vale*, the well-known West Country class engine.

The request was that she should be painted in her original form and malachite green livery, complete with a rake of Bulleid coaches. The original plan was to show her hauling the Atlantic Coast Express along the Camel Estuary between Padstow and Wadebridge. This idea immediately fired me with passion and enthusiasm because I loved this estuary – and it was my old stamping ground! Those who know it will no doubt agree when I mention its outstanding natural beauty.

The dream was shattered a few days later as the result of a telephone call. Evidently the Bulleid Society had uncovered some grave doubt as to whether No. 34023 had ever hauled the ACE in Cornwall during the time she was painted malachite green. So now a new location had to be selected. Eventually, after much deliberation, reflection and ploughing through books, and the period being narrowed down to June 1949, the committee representatives finally settled on a spot just south of Winchfield in Hampshire, sadly a lot less charismatic than the Camel Estuary! However, *Blackmore Vale* was now to be shown with a Waterloo to the West of England express on the down fast line. Nevertheless, this part of north Hampshire does have its compensations in that silver birch and rhododendrons abound here, and the railway embankments are amass with them. This cheered me somewhat, and once I had started the painting I had very soon lost sight of my earlier disappointment.

After one or two minor adjustments to the locomotive the Bulleid Society approved of the original and it went into a limited edition print. I am now looking forward to seeing this lovely engine in steam once again heading coaches of enthusiasts and multitudes of mesmerised children on special treats with their parents.

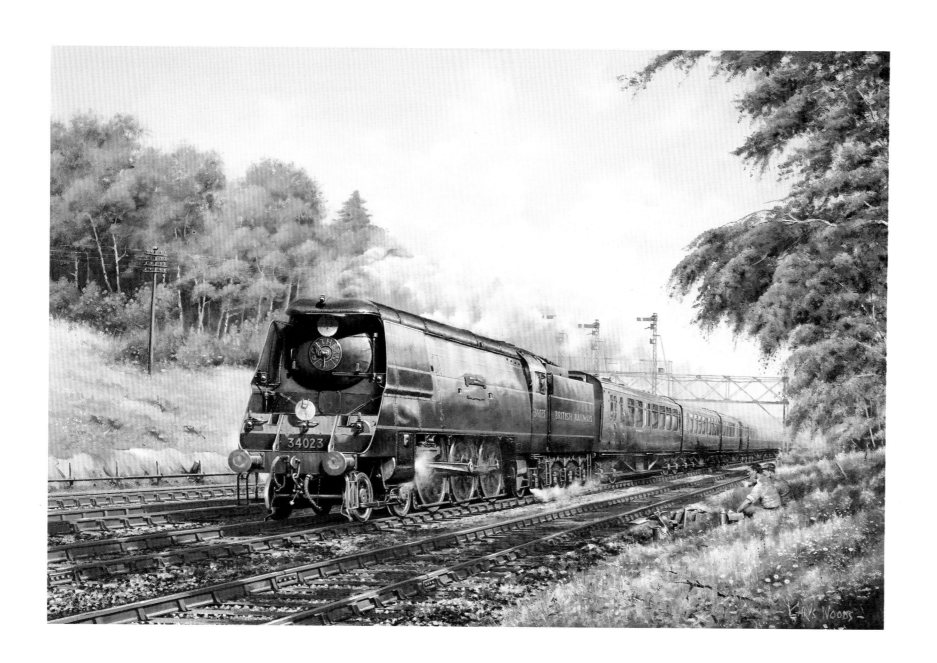

Watching

Ex L.S.W.R. Drummond M7 Tank No. 30049 meanders into Rogate with a one coach train for Petersfield, the end of the branch. No. 30049 was built in May 1905 and was eventually withdrawn in May 1962. 24 x 18 in. 1990.

The original idea was for me to paint a G.W.R. Prairie Tank No. 5526, but during the interim period Mr. Evans had acquired Rogate Station – such as it was. So when the time came for me to begin, the plan had been changed as he had decided that he would like a painting of the station as it once was in its heyday.

Rogate, sometimes referred to as Rogate for Harting or Rogate and Harting, was situated on the Petersfield to Pulborough line, which ran almost the entire length of the Rother Valley. In 1864 the L.S.W.R. was the first company to operate a train service to Midhurst, where it had its terminus. Along came a rival company, the L.B.S.C.R., extending its Horsham branch, also eventually in 1866 reaching Midhurst, where it too had its terminus. Both these companies were incorporated into the Southern Railway at the beginning of 1923, and subsequently of course, being swallowed up by British Rail in 1948. The passenger service between Petersfield and Midhurst came to an end on 5th February, 1955.

The station buildings at Rogate were originally identical with the others on the L.S.W.R. branch. There was a signal box situated at the eastern end of the up platform, but the signalling system had been dispensed with in about 1932, and from that time onwards the signal box served only as a ground frame. At about the same time the down platform became disused and the 'bus shelter' which had been built on it was removed. Nature then began to claim back this platform as her own.

When I visited the site to get the feel of the place, it really was a dismal scene. Builder's debris everywhere, it looked a shambles. The buildings had been converted into a factory in 1968 for the production of acrylic castings. Additional factory structures had been built adjoining the main buildings, one on the platform. The window frames, guttering and down pipes, etc., had been painted in a garish blue, which didn't help matters. The chimneys had been taken down at some time, and there was no sign of the signal box, though I dare say that it disappeared at the same time as the track. Struggling to remain standing on the trackbed was a dilapidated shed, its asbestos roofing sheets showing attractive rounds of orange lichen, big as doilys.

Although my visit was interesting, so far as any objective thinking regarding the painting was concerned, I found it all a bit too depressing. So I took a few photographs which I was able to study at home before setting out on the task in hand.

Mr. Evans had mulled over the choice of tank locomotive. It was either an M7 or an E4. He came down in favour of the M7 and so I chose No. 30049, which plied this line in the early 'fifties.

The porter walks purposefully alongside the arriving one-coach train, the gentle movement of which disturbs the peace of a few of the resident pigeons feeding on the platform. Seemingly, there is one only at-the-ready passenger to pick up and take on to Petersfield. All this is overlooked by a young lad from the overgrown platform opposite, totally engrossed in the placid scene before him. I perceive a kind of Wells Fargo atmosphere!

I delivered the finished painting to Mr. Evans and he was delighted to see his station resurrected on canvas and appearing as it once was. I hope that sometime in the future he also will be able to restore his station as it once was. I know that I would be really delighted then.

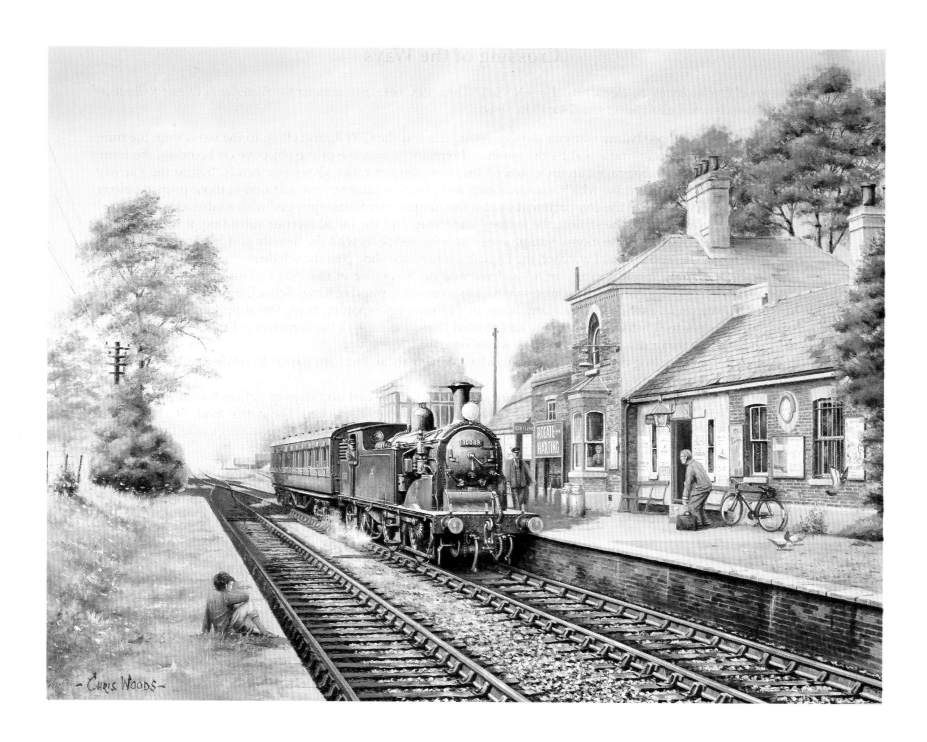

- Chris Woods -

Crossing of the Ways

The Royal Duchy, hauled by Castle class 4-6-0 No. 5011 Tintagel Castle, *passes under the Somerset & Dorset Railway as it speeds westwards near Cole in Somerset.* 24 x 18 in. 1988.

As I think back to those balmy summer days of yesteryear and the G.W.R., travelling to the seaside on the train was an exciting adventure. To find a seat by the window, I remember, was the prime objective on boarding the train. Having succeeded and the baggage carefully stowed away on the net racks above our heads, before the journey began it was necessary to determine which seaside resorts and places of interest were featured in those framed oblong photographs on the panelling of the compartment. And if the compartment was equipped with a table as well – Wow!

As the train moved out of the station, the journey underway, and the initial fervour subsiding, it was a treat to sink down into the comfort of those roomy, sumptuously upholstered seats with the heavily padded arm rests, and to anticipate the next telegraph pole as I watched the English countryside slide past the window.

All of the foregoing infiltrated my mind as I worked on 'Crossing of the Ways'. This scene, near Cole in Somerset, was witnessed many times by someone who was a one-time pupil of Kings School, Bruton, not too far from this location. He apparently whiled away many hours of free time trainspotting here. The supply by him of several photographs of the site as it is today, only really accentuated the sad demise of the Somerset & Dorset Railway, which seemed to be the only major dissimilarity from the way it once was.

At one point the painting did prove to be somewhat problematical, but I am happy to relate that the end result had a pleasing effect on its new owner.

One other recollection occurs in that I once came upon one of those cast iron railway notices bolted to a concrete post. Over the years nature had decorated it with the most attractive orange lichen. The notice read, 'Rights of Way Act 1932. The Great Western Railway Company hereby give notice that this way is not dedicated to the Public'. How pleasantly they said keep out in those days.

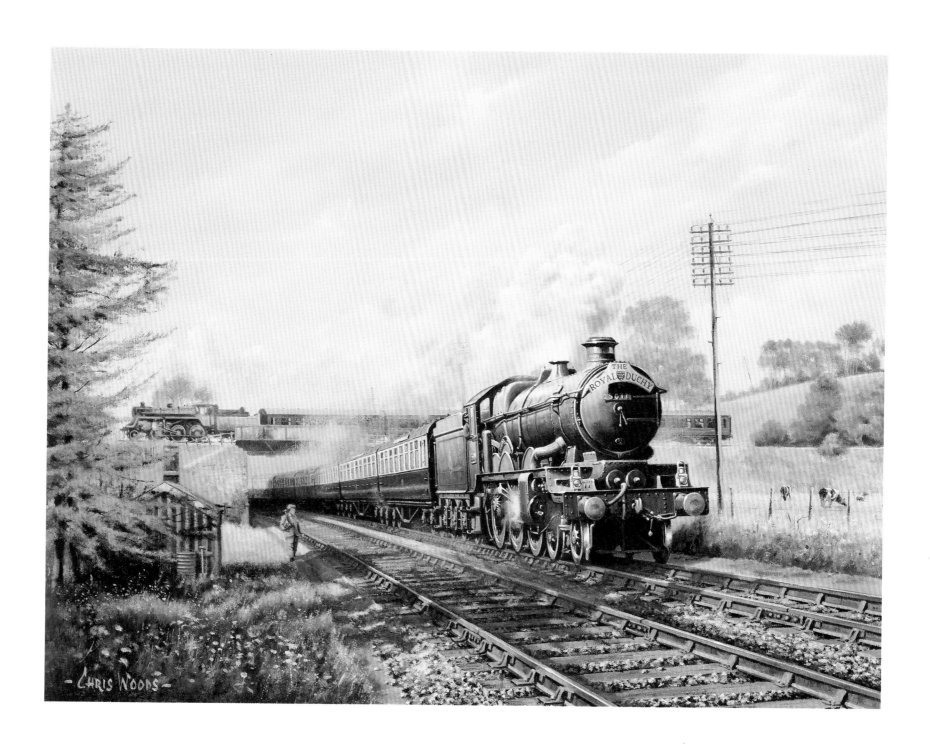

The Hayling Billy

Stroudley 'Terrier' 0-6-0T No. 32650 skips daintily over the crossing at Langstone with its three-coach Havant to Hayling Island train. Today this locomotive can be found on the Kent & East Sussex Railway as No. 10 Sutto. 24 x 18 in. 1987.

Mr. David Cowper commissioned a painting of the 'Hayling Billy', as the train was known colloquially, as he had at one time lived near the Langstone Crossing which forms the location. He supplied me with a photograph of the last scheduled passenger train before the closure of the line in 1963, and asked me to base the painting on the photograph.

The diminutive 'Terrier' locomotive, introduced by Stroudley in 1872, were the only ones permitted to cross the timber bridge linking Hayling Island to the mainland. Unlike many branch lines the Hayling line showed a profit in the early 1960s but, unfortunately, the condition of the 1,000 ft. long bridge proved to be in need of replacement. However, at an estimated cost of £400,000 it was deemed not to be a viable proposition and demolition commenced in 1966. The lower part of the trestles, which had been encased in concrete between 1928 and 1930, is the only visible evidence remaining.

At Langstone Crossing there was a crossing-keeper's hut, complete with an adjacent well-tended vegetable patch. A charming tale related to me regarding one particular crossing-keeper who apparently made wooden windmills and fixed them to the roof of the hut, much to the delight of the children who regularly travelled the line, who would cheerfully become immersed in a guessing game as to which way the wind was blowing, and how fast, as the windmill whirred around in the breeze. Oh, the pleasantries of the simple life! What of today, though? Sadly, sophistication and the silicon chip tend to rule the day, I fancy, thereby occasioning the erstwhile way of life to be frowned upon as being trite and banal by modern society standards.

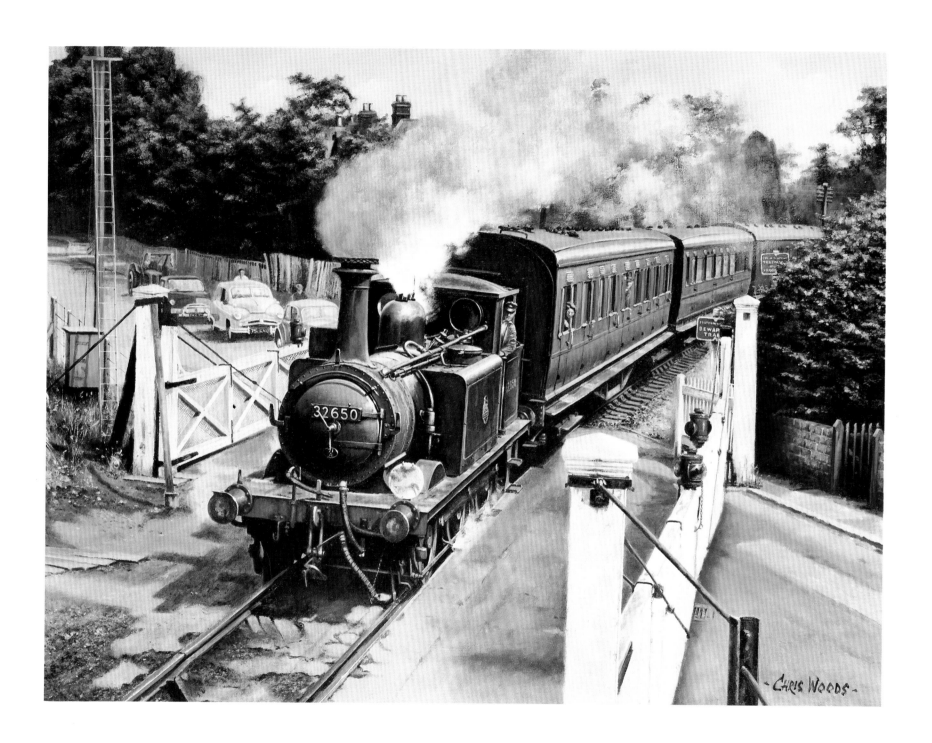

The Silver Jubilee

The Gresley A4 Pacific No. 2512 Silver Fox *is portrayed here hauling the 'Silver Jubilee' on its return journey to Newcastle Central. The couple who have alighted from their car were obviously familiar with the timing of the train and its imminent appearance. 24 x 18 in. 1991.*

The 'Silver Jubilee' was so named in honour of the Silver Jubilee of the reign of King George V, which was celebrated in 1935. It was a vivid testimony to the immense progress in the comfort and speed of rail travel which had taken place in just over a hundred years or so.

The 'Silver Jubilee' went into service between Newcastle Central and King's Cross on 30th September 1935, and from that very first day the fully streamlined crack train was highly popular, so much so, that intending passengers who had not secured their seat by booking in advance, stood the strong possibility of being left behind!

The formation of the train was originally of three articulated sets of coaches, seven vehicles in all, and mounted on ten bogies. To comply with its name 'Silver Jubilee' it was finished in silver-grey throughout, and with fittings of stainless steel.

There were four A4 streamlined locomotives built specially for the service; No. 2509 *Silver Link*, No. 2510 *Quicksilver*, No. 2511 *Silver King* and No. 2512 *Silver Fox*. These four engines were painted in the same silver-grey shade as the train.

The 'Silver Jubilee' ran for only four years when it was withdrawn at the outbreak of the Second World War and was never reinstated. During this period the train had covered approximately 540,000 miles without mishap. Following the demise of this highly prestigious train the restaurant car triplet was used between King's Cross and Newcastle, whilst the five passenger coaches had a somewhat monotonous existence for a while on the 'Fife Coast Express' between Glasgow and St. Andrews.

This painting was commissioned by John Hill, a man who can well be described as a true and enthusiastic advocate of Sir Nigel Gresley and his work, and he is, in fact, a member of the Gresley Society. He is also drawn to all forms of transport, and was indeed very keen for me to work in the SS 100 Jaguar motor car, a favourite of his and this proved to be great fun. The completed period painting was destined to evoke much wistful conversation.

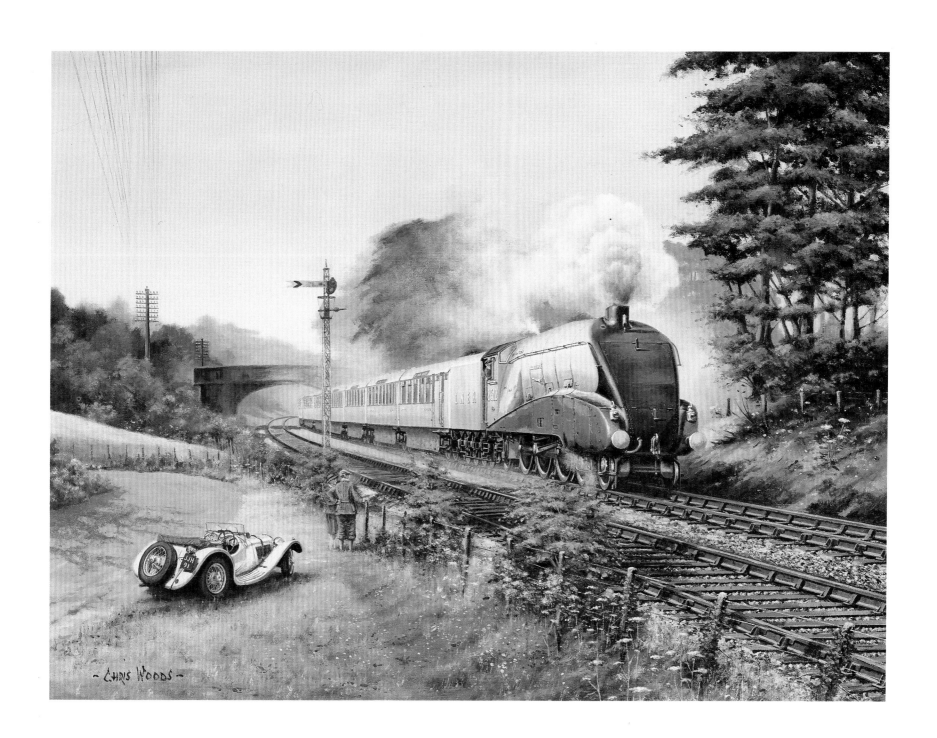

- CHRIS WOODS -

Once Upon a Time . . .

This pair of fine examples of Bulleid's genius wait patiently for their turn of duty. Merchant Navy Pacific No. 35027 Port Line *and Battle of Britain Pacific No. 34072* 257 Squadron *stand outside the shed at Exmouth Junction. Both these locomotives have been the subjects of superb restoration.* 36 x 24 in. 1984.

I acquired inspiration for this painting whilst driving homewards along the infamous M4. In the most modest way possible I had recently bought an interest in the Port Line Locomotive Project, and I was returning from Blunsdon where, at the time, *Port Line* was undergoing restoration on the Swindon & Cricklade Railway. Also standing on the railway, awaiting its turn for resurrection, was Battle of Britain class *257 Squadron*, looking very much the worse for wear.

After spending an afternoon surveying the scene and observing closely the engineers imposing their skills on the broken hulks, I motored home with one idea in mind and that was to produce a large shed painting featuring both locomotives in question.

It was still relatively early in my career and consequently my reference library was still less than moderate. Nevertheless, I did have information concerning Exmouth Junction Shed, and so I had no particular reason to hesitate in basing the painting on this well-known west country Mecca for devotee trainspotters.

I wanted to introduce a cameo of human interest into the painting, primarily to help illustrate the scale of the locomotives standing side by side. I fancy that grandad has taken his two grandsons down to the shed to see his favourite engine *Port Line*, of which he is the driver. At the same time the boys meet his friend the fireman who is already dedicated to a spot of oiling-up. Although probably ignorant of the fact, the boys are indeed privileged to be able to indulge in the attraction of the locomotive shed.

I must say I enjoyed the experience of painting to greater proportions this being the largest canvas size I had tackled hitherto. It was quite absorbing fun creating the dents and imperfections on the sides of the 'spam can' by utilising the light and shade technique.

Initially I was stuck for a title for this painting, but then my wife, Margaret, hit on the idea of 'Once Upon a Time . . .' which I considered to be very apropos in the circumstances.

A week or so after completing the painting I had occasion to see my solicitor, and hanging in his office I was aware of several railway prints. My astute perception told me that this man was probably a railway enthusiast. After the business was completed I casually mentioned my paintings, and he immediately invited me to bring my originals along. When he saw 'Once Upon a Time . . .' he became very excited as, coincidentally, the Bulleid's were his favourite locomotives. At once he wanted to buy it and really twisted my arm to sell it to him. He even offered me cash! After a lengthy 'cross-examination', I finally succumbed under the pressure and the painting was gone!

Incidentally, for the eagle-eyed, I fear that the lip on the chimney of *Port Line*, is obviously lacking in accurate profile. I regret this neglect and trust it will not sabotage any conceivable appetite for this picture.

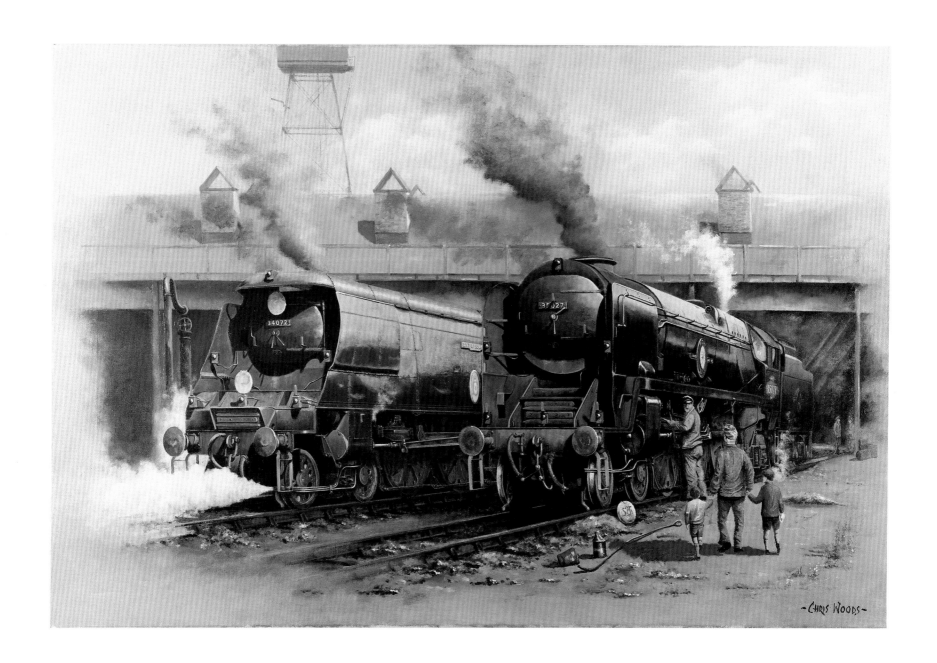

- Chris Woods -

Cambrian Way

G.W.R. Manor class 4-6-0 No. 7819 Hinton Manor *heads the Cambrian Coast Express along a particularly flowery stretch of the line, scattering a few chickens from the farm track as it goes. No. 7819 was built in 1939 and withdrawn in 1965. She has been preserved and can be found on the Severn Valley Railway. 30 x 20 in. 1988.*

When in North Wales a fascinating attraction for me is to walk into Pwllheli Railway Station – quaint, quiet, almost secretive, with green paintwork everywhere and masses of geranium-planted hanging baskets suspended from the glazed roof above.

Here is a very agreeable step back into the past, I fancy. The prevailing mood within the whole place is one of overwhelming nostalgia oozing from every quarter, romping among the regimented line of luggage trolleys parked near the waiting room door, and pausing to trifle with a couple of ghostlike milk-churns before completing a roundelay of recall via the newspaper kiosk. I am convinced that if one listened long and hard enough, one would surely be able to hear the Pwllheli portion of the Cambrian Coast Express arriving!

This daydream prompted the idea for 'Cambrian Way', the setting for which could be somewhere between Talerddig and Machynlleth during early summer – a scene that captures the essence of the former Cambrian line.

Although I am of Southern persuasion, ironically the lovely Manor class locomotive was always a favourite of mine, in fact the very first model locomotive I bought was of No. 7819 *Hinton Manor*. This painting, then, gave me the perfect opportunity in which to include the same engine, hauling the Cambrian Coast Express, though in this case minus its headboard.

On the flat marshlands where the Dovey estuary narrows, the line divides at Dovey Junction; south to Borth and Aberystwyth, and the northern route to Aberdovey, Towyn and the coast line to Barmouth and beyond. It is this line which crossed the Mawddach estuary by the impressive Barmouth viaduct. It provided a spectacular setting for passengers with the Cader Idris range as a backdrop. Those remaining on the train after Barmouth would travel onwards to Harlech, Porthmadog, Criccieth and terminate at Pwllheli – quaint, quiet, almost secretive, with green paintwork everywhere . . .

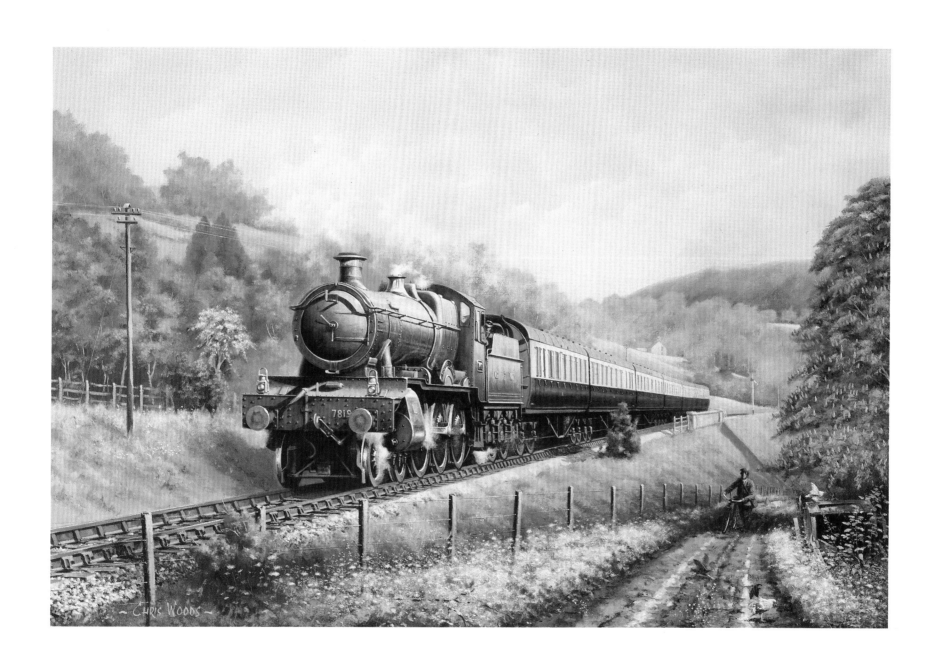

Wintry Morning

Bulleid Q1 class 0-6-0 No. 33001 is seen passing through Swaythling, as it returns a load of empty banana wagons to Southampton Terminus. This engine has been preserved as part of the National Collection and is in the care of the Bulleid. Society, and housed on the Bluebell Railway. 24 x 18 in. 1989.

"Snowy pictures do *not* sell!" I well recall the owner of a gallery once making this announcement as I perused the paintings hanging on his walls. This statement may well have been a generalisation on his part, but though I have never forgotten his words, I have tended not to hold much store by them either. The reason being is that I know folk who are very fond of wintry scenes.

No matter how much one dislikes having to grapple with the adverse conditions snow brings (my mother claims it makes her as evil as an adder), most would readily admit to the outstanding beauty of a transformed landscape, triggered overnight by a precipitation of the white stuff. Keener types will rush out with their cameras, set ready to capture the virgin snowfall on film for posterity, the resulting snaps to be labelled 'Winter 1962' – or whenever! I can lay claim to this novel diversion myself.

Personally, I have an attachment for snowy landscape paintings and, mentioning this to Jim Hodgson, he agreed quite happily for his Q1 request to be captured in a winter setting.

I chose to portray the locomotive at Swaythling, just north of Southampton. Situated there was an attractive, though not grandiose, signal box, the inclusion of which in a railway painting always contributes an appealing point of interest.

The Q1 was an austerity product of Bulleid's genius, the design of which proved to be a compatible blend of traditional features and his avant-garde ideas. He needed to save weight and materials, and in order to do this the Q1 was deprived of all unnecessary footplating, etc., and was equipped with unusual boiler cladding, the weight of which was carried on the frames. This design resulted in an overall engine and tender weight-saving amounting to about 14 tons over a conventional locomotive of similar size and power.

Often fondly referred to as 'Charlies' or 'coffeepots', these unconventional-looking engines packed quite a punch, and were regarded as having more than proved their worth in mixed traffic work.

Despite the apparent simple lines of the Q1, when painting it I found it surprisingly challenging to obtain the seemingly facile horseshoe shape of the front end. It was fun working the signal box in, and the dark tones of the pine trees in the background provides an effective contrast to the snow-covered roofs. The footprints in the snow, left by a shuffling permanent way man, help to portend a conception of time before the arrival of the train of empty banana wagons.

In the past I have painted wintry scenes during the summer months, in the heat of the day which, psychologically, I feel is probably the best time!

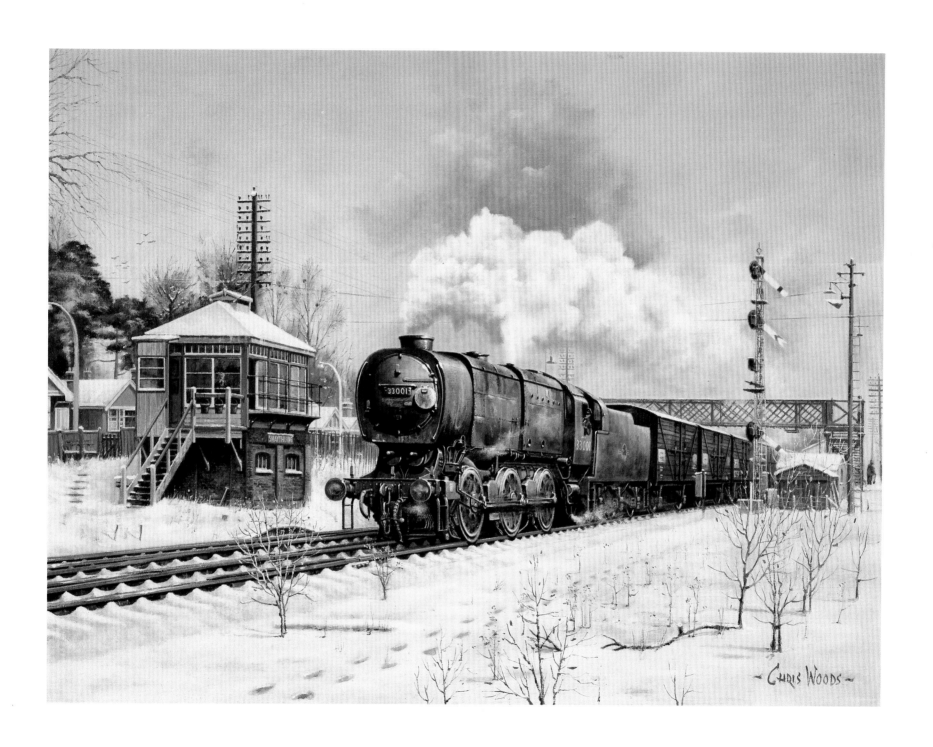

City of Lancaster

Stanier Princess Coronation class 4-6-2 No. 6243 City of Lancaster *leaving Lancaster Castle Station with a train heading for London Euston. This locomotive was built in May 1940 and withdrawn in September 1964. The apparent disinterest shown by the permanent way man may indicate that he could be one of the acrimonious railwaymen!* 24 x 18 in. 1990

When invited to paint City of Lancaster it sparked a ripple of elation because, for one reason or another, opportunity to paint subjects of the London Midland & Scottish Railway were, to say the least, sporadic. This assignment gave me an added pleasure in that the locomotive was to be painted in her original red, streamlined condition, as it was thus remembered by my client.

Curiously, at about the same time, I made the aquaintance of an old engineman who at one time had been the fireman of a Coronation class engine, and he related to me that the streamlined locomotive had created a certain disquiet among railwaymen and enthusiasts alike. Apart from the obvious disadvantages when it came to maintenance, which one can imagine brought about the occasional outburst of cursing and gnashing of teeth from the engineers within the works, in other quarters it was spoken of and referred to in a very disdainful and derogatory fashion. So many individuals considered it most unsightly – an object to ridicule.

Nevertheless, these engines also had admirers and devotees who considered them to be the most majestic, elegant and outstanding locomotive ever to grace L.M.S. metals.

It was obviously a love-hate relationship, but quite frankly I fail to comprehend the reasons for the apparent discord or why passions became fired up so. I have to say that I liked it for the way in which I saw it, aesthetically pleasing, and I was therefore happy to do this painting, especially since I had not hitherto had occasion to paint this particular class.

When specific locations are involved, such as in this case, I make every endeavour to be as accurate as I can, depending on the amount of information and reference material available. However, from time to time, it becomes necessary to introduce certain measures of artist's licence. In reality there was a series of points and tracks connecting one with another and, purely from an artistic point of view, I decided to paint them out entirely, because as the track swept away to the left, it carried the eye right out of the painting. To leave them in, therefore, would have been a distinct disadvantage to the picture overall.

This scene, Lancaster Castle Station, perpetually watched over by the castle from its vantage point on the hilltop, is a most impressive location indeed, and specially chosen by my client for sentimental reasons. He confided that his wife, in her younger days, had lived in one of the houses alongside the railway, which is as nice a reason as any for his choice.

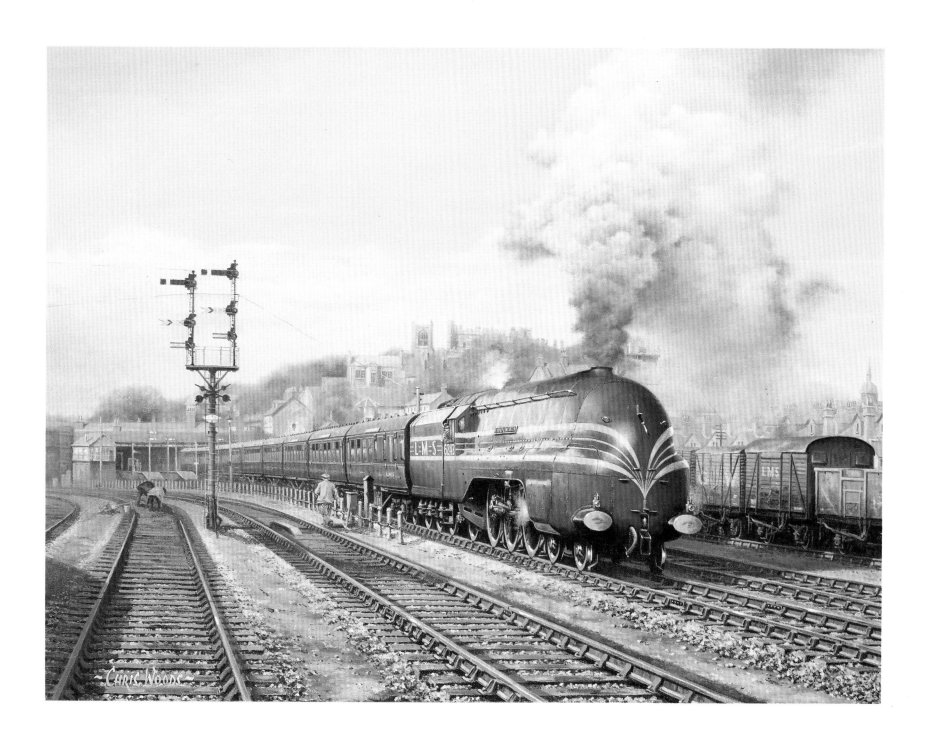

Arrival at Droxford

The two-coach train, headed by Ex L.S.W.R. Drummond M7 No. 54, has just arrived at Droxford, bound for Fareham. The linesman passes the time of day with the fireman as he manages a few minutes' respite. 24 x 18 in. 1986.

It was a delightfully rural railway. It threaded its way through the picturesque Meon Valley, in Hampshire, from which the railway took its name. This has to be some of the most beautiful countryside hereabouts. Cow parsley patterned with red campion, hangs like lace curtains in the byways. Soft rolling downland is dotted with parcels of trees, where families of rooks reside in their highrise townships, looking out over lush green pasture and meadowland which border the banks of the River Meon. Herons, still as guardsmen, poach the young sea trout from the shallows of the river, as it wends its silvery way down through the valley to slide out into the Solent at Hill Head.

For the villagers living within this valley, the railway provided a service from Tisted, Privett, West Meon, Droxford and Wickham, linking them with Alton in the north and Fareham to the south, for their major shopping or business requirements.

Don MacDonald is a nurseryman specialising in the growing and marketing of fine pinks. He had spent his boyhood in the Meon Valley, and therefore the railway had been part of his heritage. So it was no surprise that he chose to have a painting from this area, and he decided on Droxford Station.

The line was closed on 5th February, 1955, followed shortly after by the customary and all too familiar track-lifting and demolition programme. Nevertheless, the buildings of one or two stations along the valley escaped the notice of the bulldozer, and were subsequently to be privately-owned residences. Droxford was one.

The architecture of the station buildings of this railway were all basically similar, the front aspects of which were quite magnificent, and the overall appearance was indeed enhanced by the utilising of red tiles on the roofs.

The Dugald Drummond ex L.S.W.R. M7's bore the brunt of the locomotive power for the passenger trains traversing this line and, in the main, consisted of two coaches only, looking somewhat lost and incongruous when standing in the 600 ft. long platform which had been built for ten-coach Waterloo to Gosport trains.

The late 'thirties is the period I chose to depict 'Arrival at Droxford' and the Southern M7 stands at the station, which seems to be at a very quiet juncture on a balmy, summer afternoon at this lovely country station.

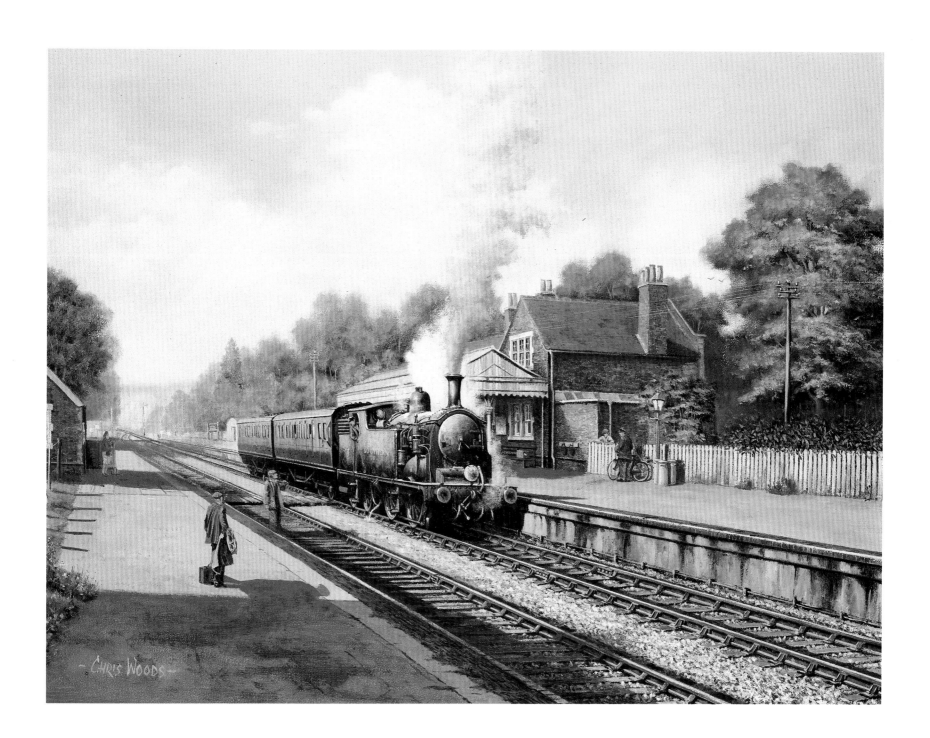

Summer Saturday

Ex G.W.R. Hall class 4-4-0 No. 4909 Blakesley Hall *brings a Saturday extra service train into Dawlish Station, bound for Paddington.* 30 x 20 in. 1986.

This is not the first time I have painted the Dawlish scene. 'Holiday' had highlighted the Torbay Express heading westwards. It had formed the centrepiece of an exhibition of my work which was held at Harrods in 1984. It had also been published as a limited edition print and this had come to the attention of one of the big publishing houses who came to me to create a railway image for them. Discussion with the company publications manager ensued and it was decided to feature Dawlish again, in its heyday, as it was indeed a popular location, familiar to many who holidayed in the West Country.

For those whose long-awaited seaside holiday at Dawlish happened to coincide with a bout of inclement weather, may well have witnessed the sea lashing up and over the sea wall, often completely enveloping the train with Channel brine as it passed along Dawlish Warren. This could indeed be very disturbing for the passengers, and these unfortunate folk would conjure an entirely different opinion of Dawlish – and not at all a popular location! In fact, many of these annual sunshine hopefuls would not give the place a second chance and, at a stroke, delete it from their list of summer holiday 'possibles and probables'. All holidaymakers hope for the sun to shine, bright at celandines, but such are the vagaries of the British climate!

As far as 'Summer Saturday' was concerned, I wanted to create one of those lazy, hazy summer days we all like to remember, when everyone equipped themselves with a carefree disposition, relaxing and doing their own thing, thereby effecting the complete holiday atmosphere.

I felt that the Hall class locomotive also suited the mood, but in this case I must admit to a technical error in that I painted the wrong type of cab handrail. The style I used did not come into use until later in the long line of Halls. For those who notice such things, and I know there are, I am sorry. I wonder if the rather nonchalent-looking permanent way man walking alongside would notice – I doubt it, somehow!

I had this painting hanging on my wall at home, that is until friends of mine visited one day. It so happened that they had particular romantic memories of Dawlish, and immediately decided that they must have 'Summer Saturday' for themselves. And so they did!

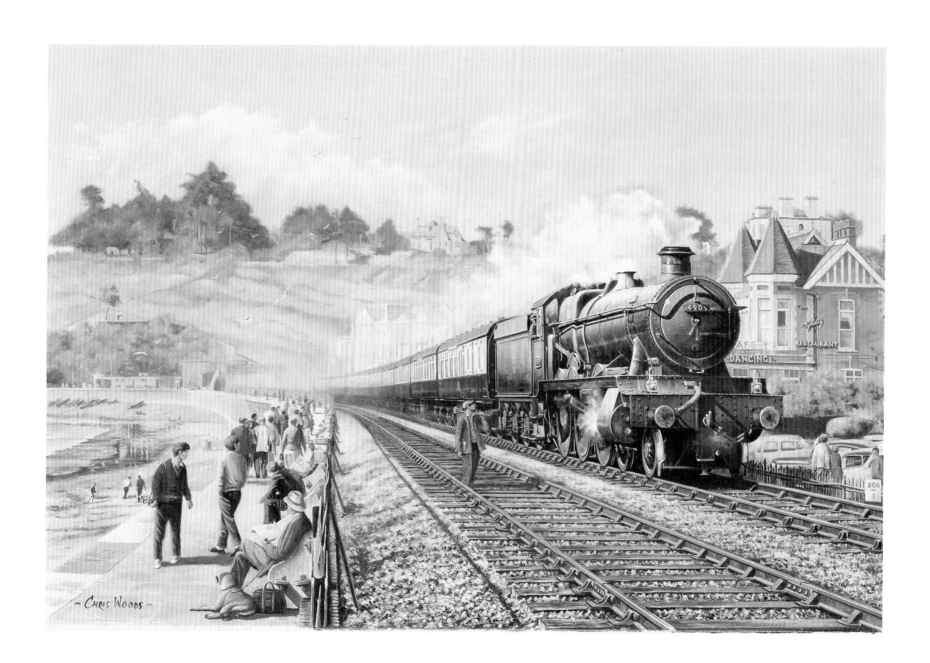

The Travellers

Wainwright H class 0-4-4T No. 1327 of the Southern Railway heads a local train through an autumn landscape in Kent, distracting the Romany girl's attention from the wild flowers. The H class was built between 1904 and 1915, the last being withdrawn in 1964. 30 x 20 in. 1988.

Over the past few years I have acquired a waiting list for my paintings and it is this list which controls the majority of my working time. Nevertheless, from time to time, I have an acute desire to paint something for myself, in other words a freelance painting. This allows me complete freedom of choice – a kind of 'no holds barred' picture; subjects which may have been lurking in the subconscious for years. 'The Travellers' is one such painting.

Whilst out walking with the dogs at a well-known beauty spot I came upon a Romany encampment from which I was able to glean enough material for me to introduce the scene into a painting. I also felt the need to paint a Wainwright H class locomotive on a branch line somewhere and as the H class operated a great deal in East Sussex and Kent I knew that this would be ideal to combine both themes.

The pastoral landscape is an imaginary one and so I decided to work in a couple of oast houses just to give the implied location a certain credibility. I introduced the little girl on the plank bridge to help create a link between one set of travellers with those on the train. I also chose to include my old yellow labrador Lizzie as an added member of the Romany family. I had had Lizzie since she was eight weeks old when we bought her from a chicken farm in deepest Dorset. Sadly she has long since left us.

I endeavour not to lose sight of the fact that normally there is a lady living in a household who perhaps is not wholly enamoured with the railway scene in the same way as her husband, and therefore I am well aware that this picture naturally carried more genuine female appeal. I still get a very warm sensation each time I see this scene as, to my way of thinking, it encapsulates all that is right in the world, what it really should be like. Utopia maybe!

A charming anecdote to accompany these notes on 'The Travellers': I received a telephone call one day from the owner of a gallery in Salisbury who was displaying in his window one of the limited edition prints reproduced from the original. He told me that he had had a man in the shop. Apparently he had string tied round his coat and round his trousers below the knee. He uttered, "Ere, mate, that's me in that picture in the window. That's my missus, my van and 'orse, but I ain't got no kids." He could well have been right.

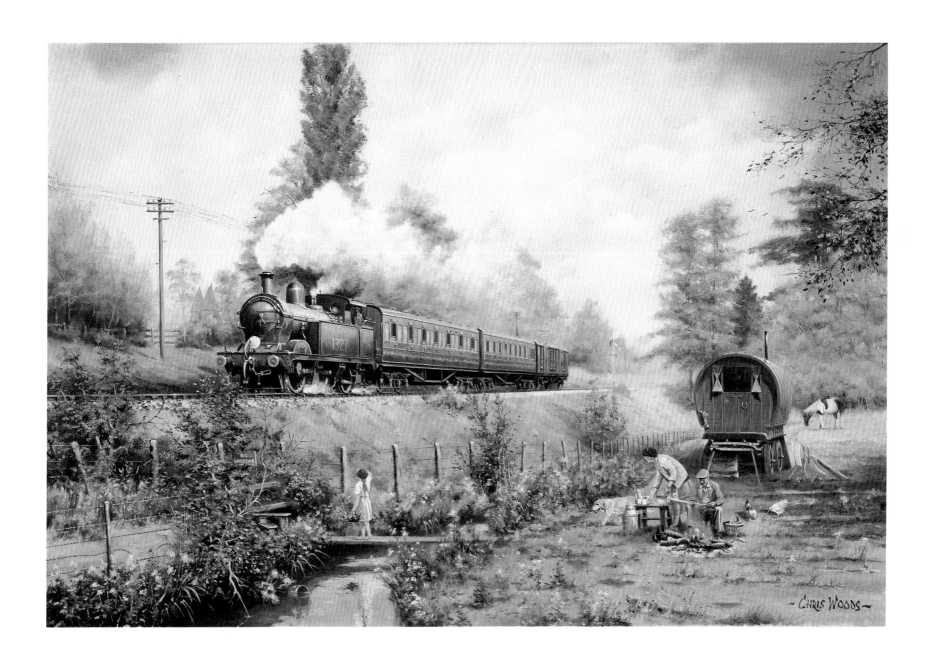

A Moment at Sherborne

Bulleid Battle of Britain class 4-6-2 No. 34051 Winston Churchill *is seen on Devon Belle duty flashing past the group of excited Sherborne schoolboys who are most likely out of bounds! The old Sherborne Castle can be seen in the background. No. 34051 forms part of the National Collection.* 30 x 20 in. 1986.

Eight cushy years in the 'seventies were spent living in Casterbridge country – Hardy's Wessex. Frequently referred to as God's Own Country – albeit mostly by Dorset men!

There is, without doubt, a particular charm about residing in this part of the universe. Picturesque cottages wallow in the vales and between them help make up the hamlets and villages blessed with exotic labels like Fifehead Magdalen, Buckhorn Weston, Okeford Fitzpaine and Winterbourne Steepleton, not to mention the Caundles, Piddles and Puddles! All sounding a trifle eccentric, but nonetheless wholly delightful.

What self-respecting gormandizer living in Wessex, I wonder, is not acquainted with the Dorset Knob or that delectably aromatic, but strangely clandestine, Blue Vinny cheese? And furthermore, midst these vales, cider seems to be preferred to ale, I fancy; where a pint of 'scrumpy' in The Buffalo can separate the men from the boys! I have heard regular imbibers engage in lengthy confab as to the preference and superiority of apples over hops. Amid curling pipe smoke these connoisseurs raise their glasses of golden brew to the light and peer into the heavenly nectar as they evaluate the quality and potential of the landlord's current barrel. Why waste time crooning over it when you can get on and swill the stuff?

So when 'A Moment at Sherborne' was being dreamed up, the foregoing and all that which was agreeable about my time in Dorset came flooding back on a tide of fondness and affinity. Sherborne was just down the road. In time I had become fairly well familiar with this ancient town of quaint backstreets and passageways, boasting an old castle, superb abbey and a commendable public school.

To include some Sherborne schoolboys in the composition I felt would be a nice touch and, therefore, it was necessary to check on the uniform for the period, which in this case was 1953. I rang the Headmaster and discussed with him my ideas. He did seem to be somewhat bemused but was indeed helpful in explaining that the boys wore grey suits and boaters. Today, however, it seems to be a lot more casual – grey flannels and navy blue sweaters!

This painting was commissioned by two businessmen whose printing companies were situated in Sherborne and in Stoke-sub-Hamdon in Somerset. I was allowed a free hand with the subject matter and so I chose to portray the Devon Belle approaching Sherborne at speed and heading west, finally to terminate at Ilfracombe, the popular holiday resort on the North Devon coast.

'A Moment at Sherborne' was subsequently printed and published by its new owners as a limited edition print.

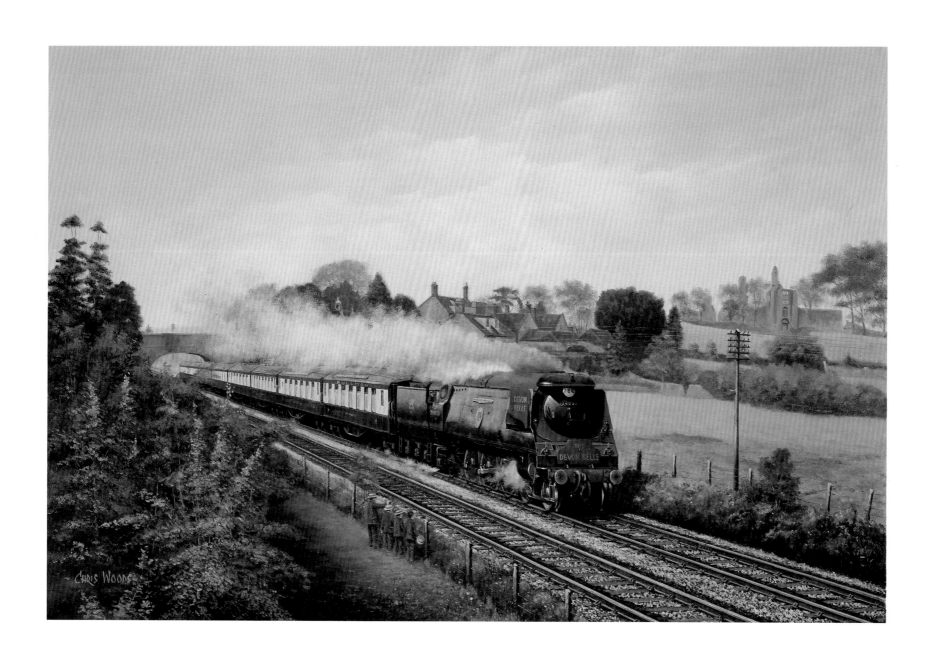

Waterloo

Adams T3 class 4-4-0 No. 563 heads a train away from Waterloo Station bound for Portsmouth, about 1901. Waiting in the platform is Drummond M7 tank No. 53. This locomotive has also been preserved. 24 x 18 in. 1988.

What a weekend! What weather! We were at Woking, attending a two-day event, described as a great transport extravaganza. It was to celebrate the 150th Anniversary of the L.S.W.R. The site was long and narrow, situated at the back of Woking Station.There were thousands of people milling around, shoulder to shoulder, and hundreds of visiting exhibitors' stands to inspect and linger over.

But the weather! The wind blew in gusts of gale-force proportions, necessitating the battening down of hatches, which in turn brought about a certain apprehension regarding parascending. There was spasmodic torrential rain which caused chaos. I saw an awning collapse under the weight of accumulated water, emptying its contents over the items for sale on the table below. The dripping traders panicked in an effort to salvage what they could of the stock. One unfortunate exhibitor's eye was focused on reams of escaping literature, as he set off in rapid pursuit in a vain attempt to effect a capture.

Then there was calm and, as if with compassion, the public were teased by bright sunshine. Multitudes of umbrellas which had locked together like stags antlers during the rut, were patiently disentangled and lowered, and anoraks thrown off as the sun penetrated its warmth. Traders busied themselves, readjusting their displays after carefully removing the protective polythene sheeting. It was only to be temporary as the whole scenario was to be re-enacted countless times during the weekend.

Our friend, Roger, who was sharing our stand, had met someone outside. He was a very well-known railway photographer, in fact a household name within railway circles. He was wearing a long black raincoat draped around his shoulders cape fashion, and a large, broad-brimmed black hat. (For those who remember such things, I can best describe him as resembling the Mr. Sandeman silhouette on the Sandeman Port label.) He had been requested to sign a copy of his book and, because of the rain, Roger had innocently offered him the shelter of the limited confines of the Printed Steam stand. As he swept through the restricted entrance he managed to knock five or six pictures to the ground with an embarrassing loud clatter. Fortunately there was no damage, and after an apology, he was gone.

What has all this to do with 'Waterloo'? I can sense a smidgen of impatience beginning to overhaul curiosity.

In a nutshell the answer is, "Not a lot". The fact is that every time I set eyes on this picture my mind is immediately filled with the happenings of that weekend – a kind of picture association.

Kingfisher Railway Productions commissioned me to paint 'Waterloo' specifically to be used as a cover illustration for a new publication, *Celebrating 150 years of the L.S.W.R.* It had to be a period scene and Waterloo about the turn of the century was settled upon. I chose to portray William Adams' elegant T3 express locomotive No. 563 in its former glory. The T3 is preserved in the National Collection.

Despite the horrendous conditions that prevailed over that weekend, it was a fantastic show, enjoyed by everyone (I think) and recalled with a sense of both warmth and fun. You may have been there.

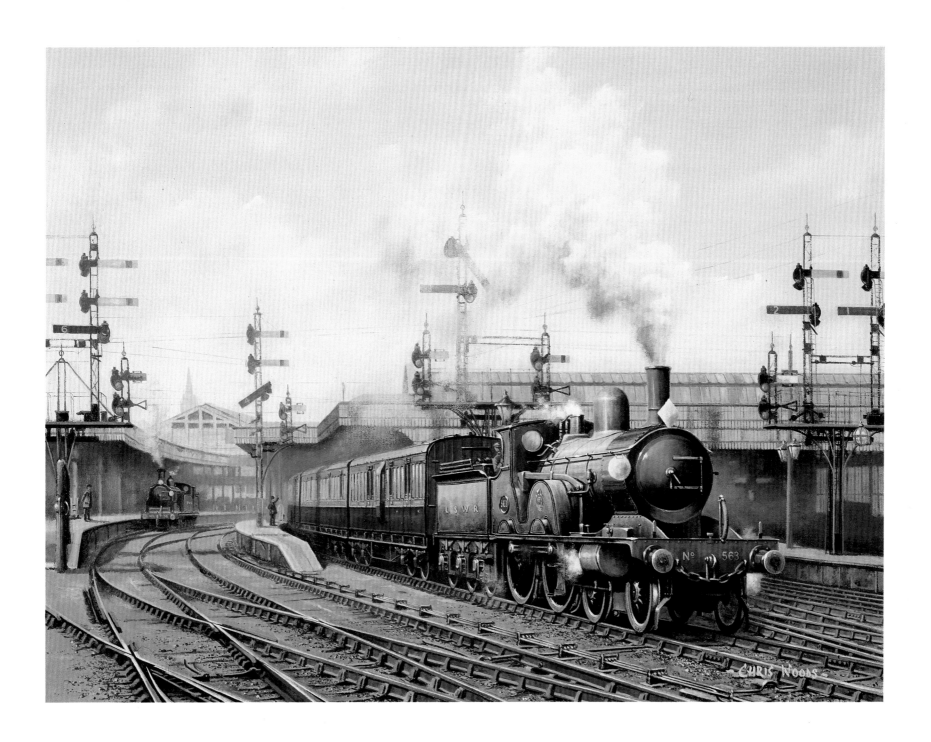

Three Ladies at Salisbury

King Arthur Class 4-6-0 No. 30744 Maid of Astolat *simmers on shed at Salisbury. She is accompanied by Standard 4 No. 76017 and West Country class No. 34007* Wadebridge. *No. 76017 has been beautifully restored and in service on the Mid-Hants Railway, and No. 34007 is owned by the 34007* Wadebridge Co. Ltd. *and is enjoying resuscitation at Bodmin, next door to her home town. 30 x 20 in. 1992.*

Shed paintings are indeed not everyone's choice. Furthermore, I would suggest that those who happen to have one hanging in their lounge must surely be the complete railway enthusiast.

The vast majority of people would only be aware of the engine shed from a distance, maybe viewed from a carriage window whilst passing by on a journey to distant parts. Like this one at Salisbury, most sheds were shrouded beneath a veil of sulphur-yellow smoke and steam, the smell of which some might describe as acrid, others (enthusiasts) as fragrant!

The cathedral-like proportions of the engine shed was a source of pure magnetism for the young schoolboy trainspotters of the day. If they were able to gain entry by surreptitiously creeping 'under the canvas' as it were, it would be a thrill a minute. With one eye out for the shed foreman, they would scuttle about in the gloom, between the sleeping giants, hastily scribbling numbers into dog-eared notebooks, like field mice in a frantic search for grain to increase their winter maize mountain.

I suppose the running shed could be held responsible for more cases of truancy than grannie's funeral. Those who were playing truant would be set on a collision course with the headmaster, and if caught appropriate punishment meted out. I wonder if it was all worth the risk of an inflicted penalty when, on reaching home and doing the all-important check, sadly discovering that over half of the scribbled numbers had already been collected before and underlined in the Ian Allan 'bible'! I dare say it was. Mind you, I never played truant . . . !

This painting gave me added impetus in that, curiously, this was the first occasion I had to paint a King Arthur class locomotive. In the old days, as a boy, I was really captivated by Arthurian legend, the Round Table, and all that stuff, and undoubtedly this is the reason the class became my favourite. But as time went by the number of the Arthur's began to dwindle in favour of the West Country 'spam cans'. So, with the typical fickleness of youth, my allegiance to the 'king' began to diminish in favour of a new 'prince', Mr. Bulleid!

There is nothing quite like a good shed picture to induce one to push the rewind button.

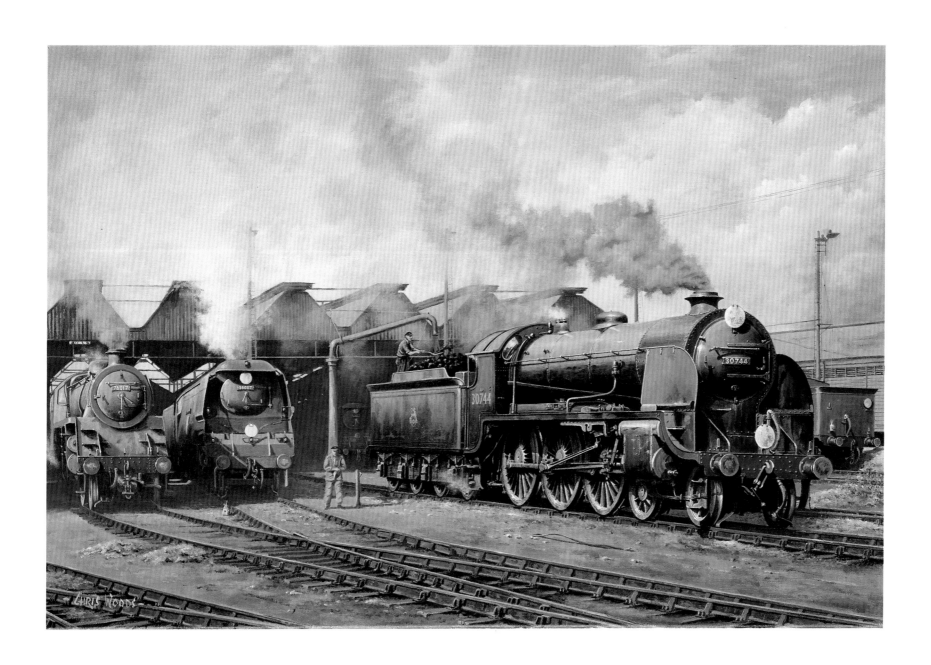

The Bournemouth Belle

Passing under the now vanished great gantry of signals, headed by Merchant Navy Pacific No. 35022 Holland America Line, *in that Indian summer of the steam locomotive of the late 'fifties, the Bournemouth Belle heads westwards.* 36 x 24 in. 1985.

A painting of the Bournemouth Belle was always on the cards. Whether seen at speed or just standing in the station, for me this train, above all others, stirred the adrenalin. There was a distinct aura about it which played havoc with the hairs on the back of the neck. A glamour train, discharging charisma from every seam.

While standing at the end of the platform, awaiting the off, the engine would be gazed upon in awe by dozens of wide-eyed, exhuberant, dishevelled schoolboys, pointing and gesticulating, with their Ian Allan ABC's and partially-consumed pencils akimbo, all anticipating the imminent departure of the train and fantasising over its journey ahead. This euphoria would be temporarily interrupted as hands were hurriedly clasped to ears at the sudden hiss of erupting steam, followed by relieving laughter as the cacophony subsided.

The more cultivated and sophisticated individuals would tend to amble the entire length of the platform to peer casually into the wonderful Pullman cars, intoxicated by the supreme coachwork and appreciative of the splendid interior decor, and making a mental note of the individual names and numbers painted in cream lettering on the chocolate sides of those unique coaches.

The Southern Railway introduced the Bournemouth Belle in 1931 to run on Sundays only, but from 1936 it became a daily service, hauled in the main by a Lord Nelson class locomotive supplied by Nine Elms shed. At the outbreak of the Second World War the Belle was withdrawn. However, in October 1946 it was returned to service in all its splendour, now headed by a Merchant Navy Pacific.

The passengers, having paid an additional Pullman supplement, were conveyed in elegant style from Waterloo to Bournemouth in two hours, on a train which, in its final years, often amounted to twelve or thirteen cars, thereby making it the heaviest passenger train working on the western main lines of the Southern Railway.

Sadly, this prestigious train finally went out of existence in 1967 with the introduction of the electrical service.

I chose to portray the Bournemouth Belle pulling away from Southampton Central. I was familiar with this station and it gave me the opportunity to 'rebuild' the wonderful ornamentally architectured clock tower, which had been demolished in the mid-sixties. It had always been a landmark, synonymous with this station, as indeed the more austere lines of the tall stone Civic Centre clock tower remains today.

This painting was chosen as a centrepiece at an exhibition held at the Russell-Coates Art Gallery and Museum, Bournemouth, in 1988. The exhibition was to celebrate 100 years of the direct line to Bournemouth from Waterloo.

'The Bournemouth Belle' hangs in our home today. My wife, Margaret, had fallen in love with it and so I was very pleased to give it to her as a small token of my appreciation for all her devoted loyalty and support she afforded me in those difficult early days of my career, and in a curious way this painting has become a special bond between us.

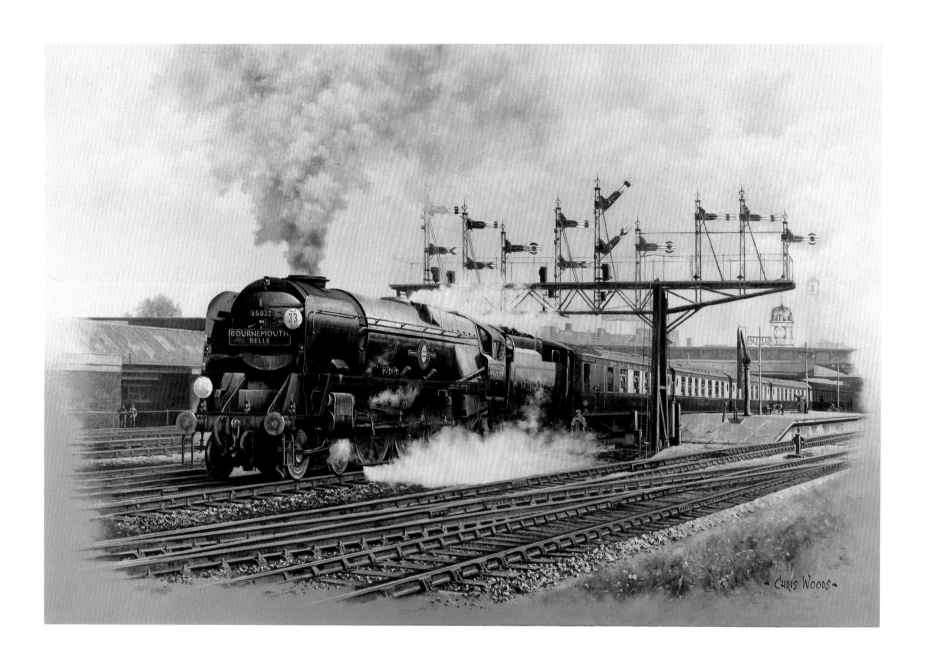

The Secret

The locomotive is a G.W.R. 0-6-0 'Dean Goods' No. 2481 which could frequently be seen on the byways of the Central Wales Division in the 1930s. She was built in 1896 and was withdrawn from service in 1940. 30 x 20 in. 1989.

I am a romantic – I acknowledge it elsewhere in this book – and 'The Secret' is a romantic painting. It was inspired by something I saw somewhere in mid-Wales whilst on a journey to our holiday hideaway on the Lleyn Peninsula in Gwynedd. We make a twice-yearly drive of some 300-odd miles, lured by an enigmatic Celtic charm to this most magical spot. Here is a place for relaxation, contemplation and battery-charging – no telephone, relatively few people and an added bonus of no M27! One can imbibe both the aura and tranquility here whilst strolling across seemingly endless sandy beaches; by sitting quietly observing the private lives of the seals as they indulge in their daily ablutions whilst lolling about on rocky outcrops; or just simply wandering through the lanes and along cliff-tops, among countless wild flowers . . . and sheep! All this fills me with a sense of warmth, well-being and reverie.

The general landscape and countryside of Wales is full of enchantment and charisma, and so when I began this painting it was very easy for me to drift back in time to the 1930s, and so produce 'The Secret' as a period piece. I soon retrieved that inner feeling of warmth and well-being as the scene developed.

Towards the end of one of those heady, halcyon days of summer, and after long toil in the fields, the young farm worker has been met at the gate by his sweetheart for a spot of furtive courting as they ride towards home together on the back of the gentle shire-horse. As the local train passes, the rendezvous has been duly noted by the engine driver – her father!

Bodmin at Ropley

West Country class Pacific No. 34016 Bodmin *is seen arriving at Ropley Station on the Mid-Hants Railway with a train for Alton.* 30 x 20 in. 1991.

'Steam Aid' had been launched by the Mid-Hants Railway as a fund for providing extra financial support. In view of this a scheme was devised to produce fine art prints from a painting, and from the sale of each print 'Steam Aid' would benefit by the payment of a royalty. Ropley Station, as it is today, was chosen as the location principally for its charming station buildings which had been beautifully restored to recapture the delightful L.S.W.R. ambience with original company colours and 'barley sugar' lamp posts, and not forgetting the topiary which has always been synonymous with the station. This restoration won for Ropley the Best Preserved Station award in 1981 in the annual competition organised by the Association of Railway Preservation Societies.

A slight dilemma presented itself when it came to selecting the locomotive for the painting. However, after some contemplation I finally decided to feature the Bulleid West Country class *Bodmin*. She is generally regarded to be the 'flagship' of the Mid-Hants Railway and arguably the most popular engine of the working fleet at Ropley.

The Hampshire County Council Museums Service generously sponsored the painting, and an arrangement had been made for me to officially hand it over to the representatives of the H.C.C. at a small ceremony held on the platform at Ropley, and I was delighted to oblige. '*Bodmin* at Ropley' now hangs on permanent display at the Curtis Museum in Alton, Hampshire.

~ Chris Woods '91 ~

The Cunarder

Lord Nelson class 4-6-0 No. 30850 Lord Nelson *gently lifts the heavy boat train away from the Ocean Terminal building loaded with transatlantic passengers bound for London. The* Queen Elizabeth *is tied up alongside awaiting her turn round time.* 24 x 18 in. 1987.

'The Cunarder' was an evocative painting for me to undertake and, without doubt, this scene will be exceedingly so for many folk, for one reason or another.

Many years ago my aunt had left England to live in America and from time to time sailed back to these shores to visit her family. She had been able to experience the pleasures of Cunard's distinguished transatlantic liners which spanned the era of her voyages. She sailed a number of times on the *Mauretania, Queen Mary, Queen Elizabeth,* and finally the *QE 2* (which included the eventful occasion in May 1972 when a bomb hoax had necessitated the *QE 2* stopping in mid-Atlantic to embark parachuting bomb disposal men of the SAS and SBS, who had been flown out by RAF Hercules aircraft. Their search was fruitless and the bomb scare proved to be without foundation). During her Atlantic crossings she received invitations to dine and to cocktail parties from the respective captains. When it was time for her to return to the States, I can recall going aboard the *Queen Mary* and *Queen Elizabeth* to say 'bon voyage', and climbing the wonderfully ornate staircases between decks and being captivated by the magnificent decorative wood panelling and the paintings in the cabin-class lounges and restaurants. It was truly something to behold!

The prestigious Southampton Ocean Terminal was opened by the then Prime Minister, the Rt. Hon. Clement Atlee on 31st July, 1950. The building had cost £750,000 and had a length of 1,297 ft. and was 111 ft. wide. There were two large luxurious lounges provided for the passengers on the upper floor where they could avail themselves of the refreshment buffets, W. H. Smith's, and the telephones. Banking facilities were also to hand as were the customs examination halls. Passengers were able to embark or disembark by means of three sets of hydraulically-operated telescopic gangways fitted to the outside of the building.

Those whose destination lay in London were provided with Pullman boat trains to convey them to the metropolis in the comfort and opulence to which they had been accustomed during their transatlantic crossing.

'The Cunarder' was one such boat train and I have depicted her here just pulling away from the Ocean Terminal, to be observantly marshalled by flagmen as she warily threaded her way out of the docks, across the main road, on through Southampton Terminus and hence on to Waterloo.

A restricted edition print was published from this painting which proved to be a popular and nostalgic acquisition for many. One man claimed that he was the flagman in the foreground!

- Chris Woods -

A Winter's Tale

A4 Pacific No. 4498 Sir Nigel Gresley *is seen on Flying Scotsman duty speeding north, through a rimed mist and out into winter sunshine.* 24 x 18 in. 1987.

This was the first time I had endeavoured to paint an A4. At that particular time the eyes of the railway world seemed to be focused on *Mallard* so I deliberately decided that I would feature No. 4498 *Sir Nigel Gresley*.

I had been in touch with Mr. Gordon Pope, a Director and Treasurer (and now Chairman) of the A4 Locomotive Society Ltd., who had expressed an interest in the painting, which he subsequently decided to buy.

As a result of this meeting my wife, Margaret, and I were invited to take a trip on the next steam special to be hauled by No. 4498 out of Marylebone Station to Stratford-on-Avon, 'The Shakespeare'. We will never forget that trip! It was the most wonderful treat, complete with a superb lunch *en route* and to top it all, as if by magic, Gordon produced a bottle of champagne from the luggage rack above our heads.

As we sped through the countryside the weather tried its utmost to upset our day by lashing rain against the carriage windows but it was fighting a losing battle as we were all spurred onwards by the regular sounding of the chime whistle from *Sir Nigel* at the front end.

On the return journey arrangements had been made for me to ride on the footplate. I was given the nod just after we had passed through Banbury, and I made my way forward and up into the corridor tender – this being an experience in itself – pitch dark and narrower than I anticipated. I was jostled against the sides of the tender as I made my way to the door at the end. As I cautiously opened it and stepped down onto the footplate I realised I was now somewhere which was sacrosanct, somewhere I had never before been privileged to ride. It was some time before my ears became attuned to the tremendous noise emanating from the locomotive as we hurtled along. Men, women and children alike were running to the bottom of their gardens to cheer and wave to us as we passed by heading homewards. Is this what it would be like to be a royal, I wondered!

After about twenty miles riding on the footplate I made my way back to meet up with Margaret again and to thank my hosts Gordon, and his charming wife Sheila, for my experience up front from which I was still tingling with excitement.

'A Winter's Tale', like so many of my paintings, has been good for me as it proved instrumental in my meeting new friends; one of the joys of my work.

The Viaduct

Ex S.R. Drummond 0-4-4 M7 No. 30054 at the head of a push-pull train, sets out from West Meon Station across the viaduct on its journey along the Meon Valley to Alton. 24 x 20 in. 1990.

There is something appealing about a viaduct. I am fascinated by the way that the vast majority have become moulded into the surrounding landscape with a certain empathy, mostly down to the indulgence of nature. A viaduct arouses intrigue when one considers how such a structure was constructed many years before; how many navvies were involved, transportation of materials, etc. The West Meon Viaduct was such a structure, though long gone since 1956, never to be forgotten by the local folk as it had become part of their heritage. At an estimated cost of around £10,000, this four-arch girder viaduct had been constructed from 725 tons of steel, and it carried the railway track some 62 feet above the River Meon. It formed part of the old Meon Valley Railway which ran between Fareham and Alton in Hampshire, a much loved stretch of railway, its passing long lamented.

So, when Mr. Ince, a retired schoolmaster who lived in the village of West Meon, asked me if I could resurrect on canvas the old viaduct, I jumped at the chance.

During my visit to discuss the painting I was shown around the large charming garden belonging to my host, in which he had built a magnificent garden railway which included a model of the viaduct in question which carried the track across a large goldfish pond and into the station and beyond.

At some time or other he had also acquired an old showman's caravan which he had restored to its former glory. It was lovely. He asked if I could include it somehow in the painting, and I detected by the way he gazed at the caravan that he was indeed extremely fond of it, so I quickly decided there and then that I would make a feature of it. When it came to painting the scene I invented a couple of travellers who had unhitched their horse so that it was able to drink from the tiny stream running alongside the lane. This in turn enabled me to display the caravan to reasonable advantage.

Although Mr. Ince is a railway enthusiast and an admirer of the M7 tank locomotive, when he saw the finished painting he was particularly excited to see his caravan in the foreground. He seemed genuinely pleased and we wandered across the road to The Thomas Lord and had a celebratory lunch.

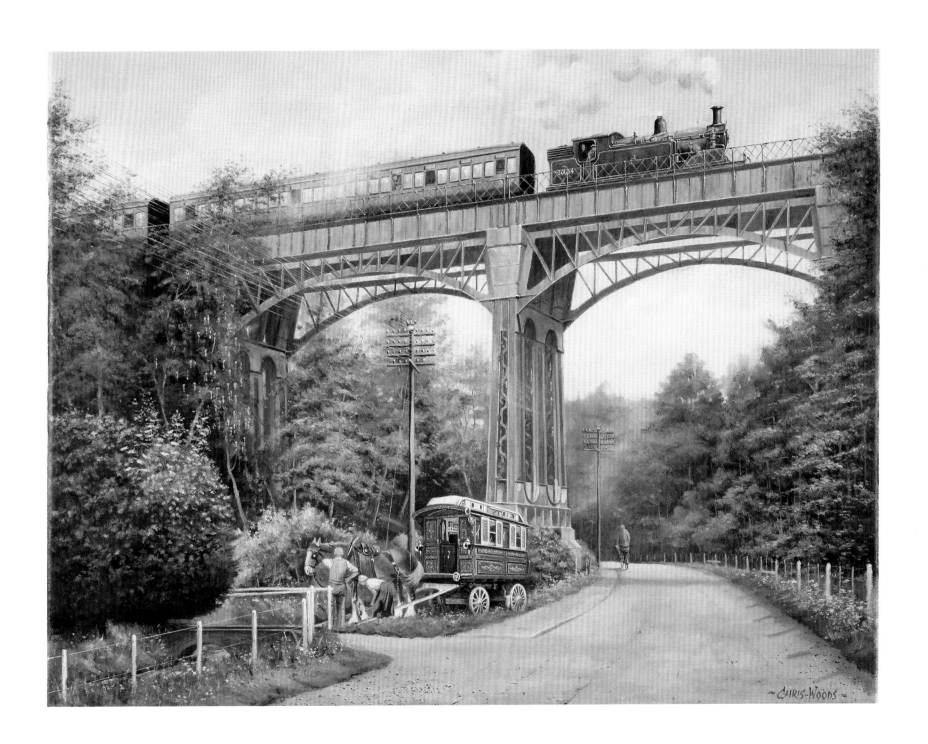

The Trainspotters

Drummond T9 4-4-0 No. 30732 heads a train away from Cosham Station en route for Southampton Terminus during the late 1950's. This locomotive had quite a spell of service on the Meon Valley Railway. 24 x 18 in. 1988.

The odds were stacked against it. It *would* have to happen!

Mr. Roger Banks had, as part of his collection of railway memorabilia, the number plate from the smoke box door of T9 No. 30732. As part of a series of paintings I had provided for a railway calendar was 'Winter Freight' which featured T9 No. 30732.

Mr. Banks' eagle eye had spotted the unlikely coincidence when a copy of the calendar came into his possession. This stroke of chance obviously motivated him to invite me to paint him 'The Trainspotters'.

Cosham was the scene of his boyhood trainspotting forays, and so I embarked on a spell of research there. In company of a friend I visited Cosham Station and was not surprised to find a number of major changes since the days of the late 'fifties, which was to be the period for the painting. A block of flats was standing on the site which had been occupied by the signal box and railwaymens' 'privy'; the siding had gone, together with a number of grim-looking concrete invasion blocks, and standing within this area today near the crossing gates, somewhat ironically I feel, is a careers office.

Overlooking this scene today towers an enormous DSS building, dominating the surrounding area. I had been availed practically a guided tour of this building in an effort to capture the most advantageous level and angle for the portrayal of the subject. This tour followed a somewhat lengthy attempt to convince the sceptical and somewhat bemused security guard of my reasons for being there. One could read it in his eyes. "Oh, yes, sir. Pull the other one!" Nevertheless, after several phone calls to offices on various levels, entry to that which seemed sacrosanct was achieved. Now if my friend and I had been wearing black-banded trilby hats, long trench coats and carrying violin cases . . . I wonder? . . . Seriously, I was truly grateful of his efforts, and indeed has my sincere thanks.

Roger Banks had requested to be represented in the painting as one of the trainspotters, and for this purpose had supplied me with several snapshots of himself as a young lad. These, I believe, had been extracted from his mother's photograph album for my guidance.

On his own admission, Mr. Banks was not given to show much in the way of emotion. When he came to collect the painting, however, he did produce a very broad smile as he recognized the engine number from his collection featured in yet another picture.

This painting was subsequently published as a print, the sales of which have been very successful, confirming the widespread affection for the old T9 'Greyhound' is still alive.

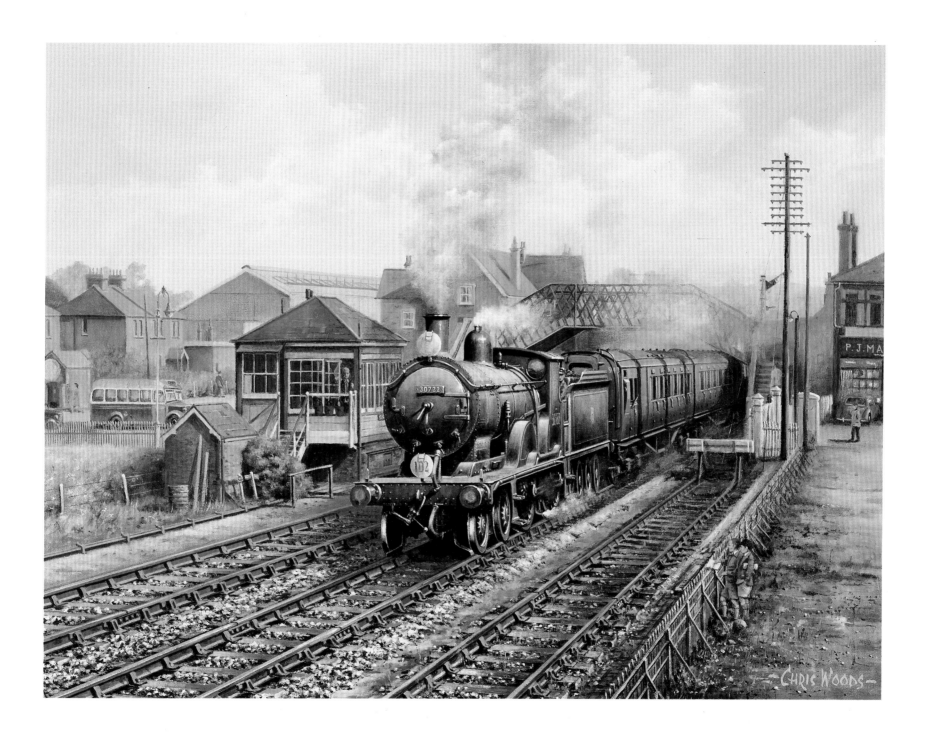

Time for Thought

Ex G.W.R. Castle class 4-6-0 No. 5026 Criccieth Castle *hurries a holiday express westwards on a sultry August afternoon.* 24 x 18 in. 1986.

"There was no finer sight than to see a Castle with a rake of chocolate and cream in full flight through the English countryside."

"Nostalgia strikes again", I thought, as the steam railway guru, obviously with a penchant for the Great Western Railway, aimed his pronouncement at me whilst attending an exhibition of my work. "To each his own", I mused, as I smiled, and politely agreed with him.

I quickly realised he was trying to tell me something, and I began to regret my foolishness in not having an appropriate painting displayed, which may have satisfied his whim.

I had to rectify the situation at the next opportunity. I sat back, with closed eyes, and visualised *Criccieth Castle* in a summer landscape . . . alongside a silver stream, where kingfishers plunge on the wayfaring stickleback, and smart dippers, wearing tuxedos, curtsy at the water's edge, while moorhens utter their bicycle-bell kirrrup as they dodge coyly among the yellow flags.

Fragrance of blossom fills the air on a drowsy afternoon as the approaching train interrupts the almost imperceptible sound of the summer breeze as it wafts through the tall pink grasses on the bank . . . ratta-ta-tat, ratta-ta-tat, ratta-ta-tat, ta-ta-tat, ta-tat, ta-tat, tat, ta, ta . . .

After the train's passing of just a few moments, it's still once more, and the sounds of summer return to the ear with the soporific hum of busying bees, drifting from bloom to bloom on their nectar safari . . .

Whilst I was sampling this spell of dreamy meditation, a felicitous title emerged from my haze. I would call the painting 'Time for Thought'.

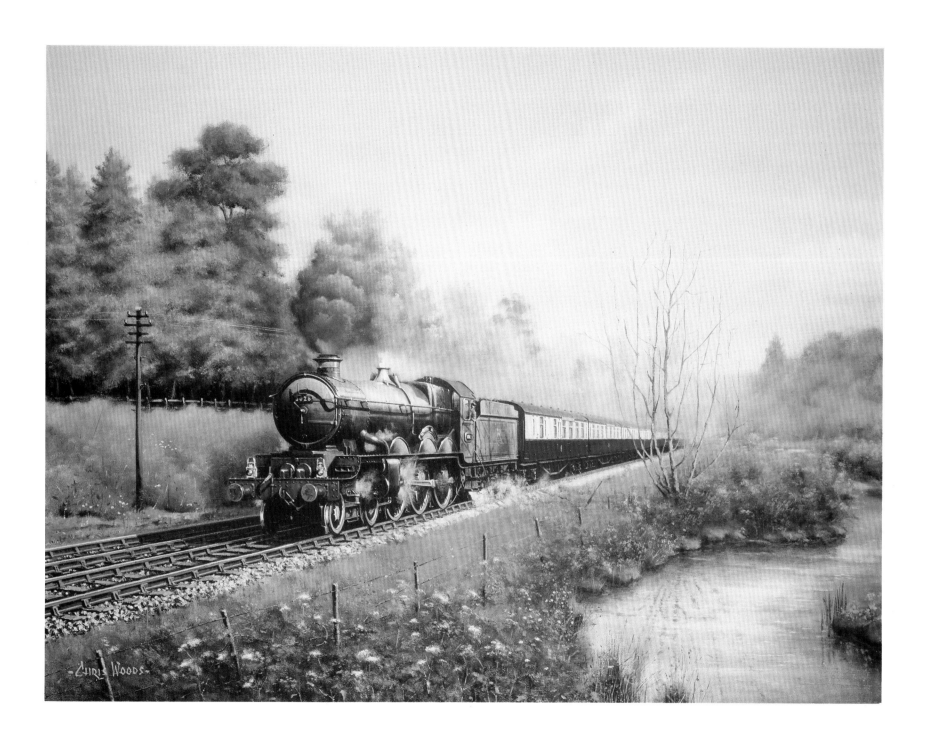

Waiting at Botley

Ex S.R. U class 2-6-0 has arrived at Botley with a local train from Eastleigh, and waits patiently for the right away to Fareham. The U class was introduced in 1928 and was a rebuild of Maunsell S.E.C. K class ('River') 2-6-4T which had been introduced in 1917. 20 x 16 in. 1985.

I had a brother-in-law, Wilf Jordan. He was a person of extreme ability – a technical man and a design draughtsman by profession. But above all a man of courage.

During the war years he was on the staff of Vickers Armstrong Supermarine and was greatly involved with the production design of various marks of the illustrious Spitfire, of which, naturally, he was justly proud. In later life his skills had been required by the giant electronics company, Plessey.

His wife, Hilda, had a birthday coming up and Wilf had the idea of giving her a painting of Botley Station. At first it did seem a mite unusual but, on hearing the background, it began to take on a certain significance.

As a young girl, Hilda used to stay from time to time with her aunt at nearby Bishops Waltham (nearby being about five or six miles). She often had enjoyable walks across fields of inquisitive Friesians and through meadows bright with king cups and lady's smock, climbing a stile at every corner, until eventually arriving at Botley Station.

By looking over the road bridge she would watch the trains and the regular activity of the porters as they loaded baskets of strawberries for transportation to Covent Garden and the like. (This is quite a strawberry-growing area.) One thing she claims will never be forgotten was the sight of spring time primroses; the banks on either side of the track were just yellow with them.

And so Hilda has fond memories of the railway scene at this Hampshire village of Botley.

Although the station is still in use today, the old buildings are no more. However, the signal box is still *in situ*, but devoid of all signalling equipment. With this and all other relevant information to hand, I began to compose the scene 'Waiting at Botley'.

Unfortunately, I inadvertently overran the allocated time schedule for the painting, and so consequently Hilda's birthday present was somewhat belated. But I do believe she forgave me!

Tragically, Wilf was destined to spend the last twenty-three years of his life as a paraplegic, confined to a wheelchair. He had set about building an interest for himself in computers, and also especially as a radio ham. During those hapless years of extreme discomfort his voice became well-known to many across the airwaves of the world. But despite these interests, I believe he was never ever able to come to terms with his lamentable situation and, sadly, his illness finally overtook him in 1989.

I am able to see 'Waiting at Botley' quite frequently, but never without pangs of poignance.

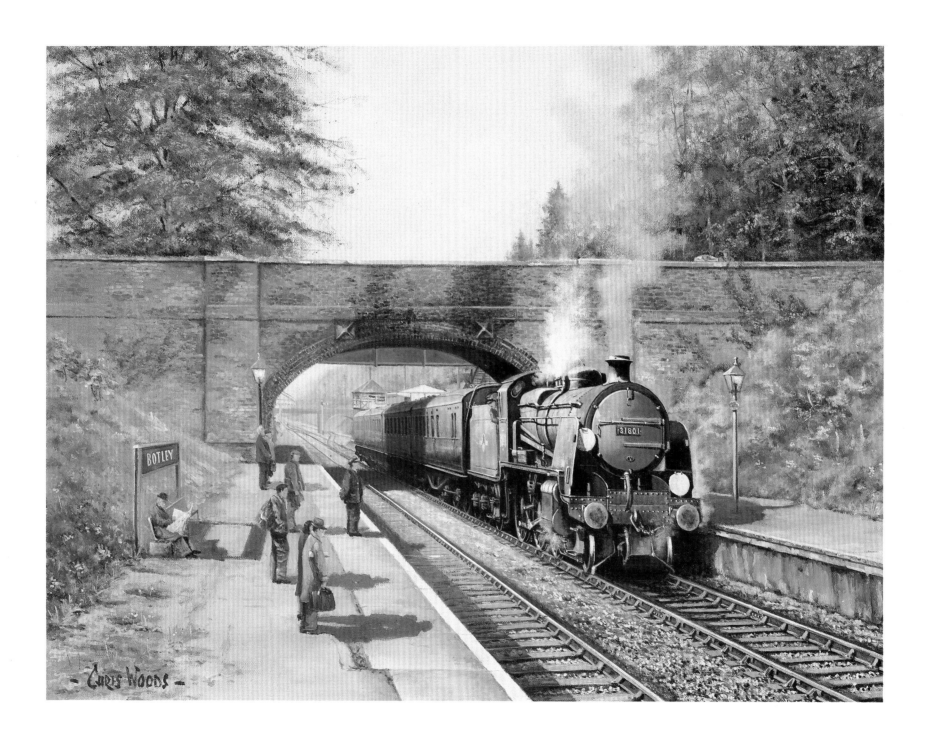

Evening at the Shed

West Country Light Pacific No. 34105 Swanage *is ready for late turn duty to Waterloo.* Swanage *has been wonderfully restored and operates regularly on the Mid-Hants Railway between Alresford and Alton.* 24 x 18 in. 1987.

Eastleigh Shed! My old stamping ground!

The memories of many happy times here have been recalled on countless occasions. When one was an impressionable young lad of a tender fourteen years, one could not fail to be completely overawed by the sheer enormity of the locomotives. They were of Snowdonian proportions, housed within their comparably cavernous pad of gloom and grime, clinker and ash.

The running shed, as we used to call it, was a place of unparalleled mood and atmosphere of sights, sounds and smells. The gentle hissing of absconding steam, combined with the sensuous smell of hot oil, emanating from the wonders and mysteries of the Walschaerts valve gear on a Pacific locomotive, is something which becomes ingrained in the memory bank for ever. Close proximity to a preserved locomotive today, can elicit these same sensations from the past. Well, for me, almost. If I close my eyes!

Eastleigh Shed was juxtaposed to Southampton Airport which, for me, proved to be an added attraction in those erstwhile years. If it was not possible to visit the shed, either by reason of an over-zealous railwayman near the gate, or the lack of a visitor's permit (which I did manage to obtain occasionally), I would sally on towards the airport, where I contentedly watched the comings and goings of the aircraft of the day.

The beautiful lines of the de Havilland Rapide spring readily to mind. At that time this fine biplane was operated by B.E.A. on their Channel Island routes, primarily to Alderney. Depending on the amount of baggage to be transported at the time, the Rapide could fly up to eight passengers across the water to these popular holiday islands. In the early 'fifties B.E.A. introduced the ubiquitous Douglas DC3 to these routes, and the Pionair, as this aeroplane was known, was able to carry three times the number of passengers. It was in 1956 that I savoured this extravagance myself.

It was in the same year that the Rapide was finally withdrawn from service by B.E.A. Nevertheless, I remember this lovely old kite with fondness and when 'Evening at the Shed' was on the easel, I did not hesitate to include it. It adds authenticity to my interpretation of this scene as I recall it.

The Bulleid Light Pacific, in the company of a Z class and a 700 class 'Black Motor', simmers patiently as she awaits the arrival of her crew. There in the background appears to be a conversation in progress between the Shed Foreman and a subordinate. They're probably putting the world to right, or maybe discussing the latest Dick Barton episode.

'Look out, Snowy, Jock...!'

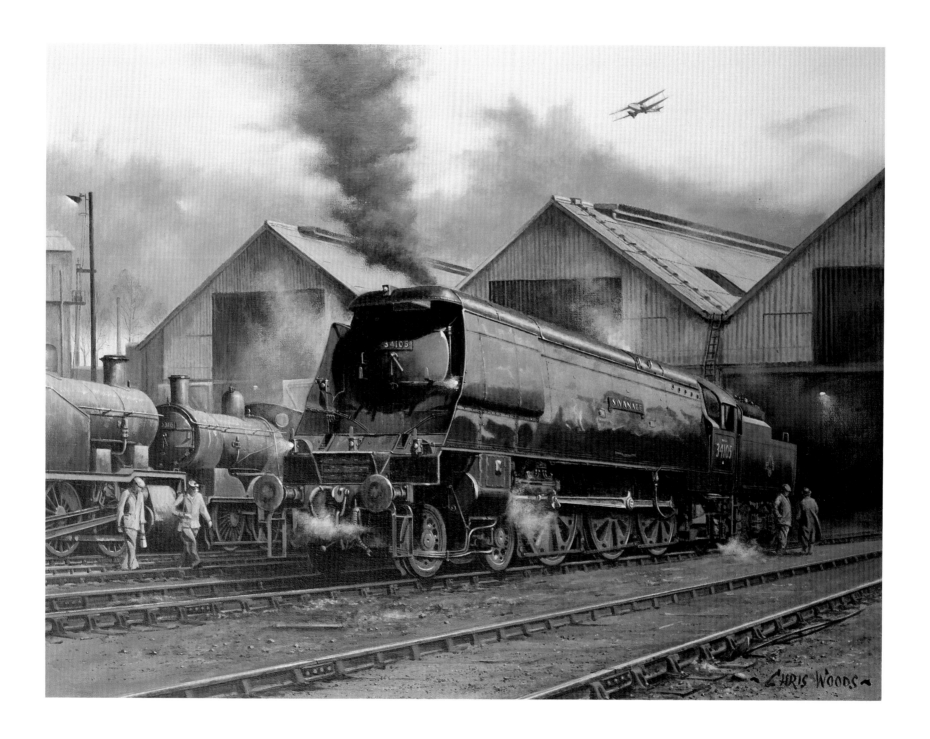

Lion

No. 57 Lion *glides silently past a gang of permanent way men as they work alongside the track during the heat of the day.*
20 x 16 in. 1986.

There was a time, in my young days, when I was quite susceptible to the odd mild aberration or two, when I tended to go off at a tangent in an attempt to fulfil some crazy ambition derived, maybe, from watching the 'run machine' Everton Weekes and 'Those two little pals of mine, Ramadhin and Valentine'; or prompted by the genius of a Gene Kelly and Rita Hayworth musical; or sparked off by the scientific rumblings of 'Quatermass' on the box. Whatever it might have been it was, of course, complete and utter fantasy on my part. A delusion.

Though undoubtedly adulthood quickly apprehended this idiosyncrasy, thus curtailing its development, and responsibility over the ten years has kept it on remand, I have to admit to the occasional propensity today, albeit to a far lesser degree and of very minor proportion. Also this eccentricity has changed tack slightly in that, from time to time, I develop a need to seek out something of the unusual to paint, and get quite excited at the prospect. There is usually one snag. If it is not possible to work on the idea almost immediately, the inclination is lost – maybe for ever.

'Lion' is a result of one such aberration. I had a sudden impulse to paint something really antiquated, and *Lion* fitted the bill perfectly.

Lion was built in 1838 for the Liverpool & Manchester Railway. She ran on this railway and then the L.N.W.R. until 1859. She was sold to the Mersey Docks & Harbour Board which had set her up on blocks and used her as a stationary engine driving a pump, this task continuing until 1928. The L.M.S. subsequently took her into Crewe Works where she was overhauled and restored.

Lion appeared at centenary and anniversary celebrations from time to time, but I suppose her real claim to fame was when she appeared in the British film comedy 'The Titfield Thunderbolt', made in 1952, which brought her to the attention of the public at large.

She is owned by the Merseyside County Museums and remains the oldest working locomotive in the land.

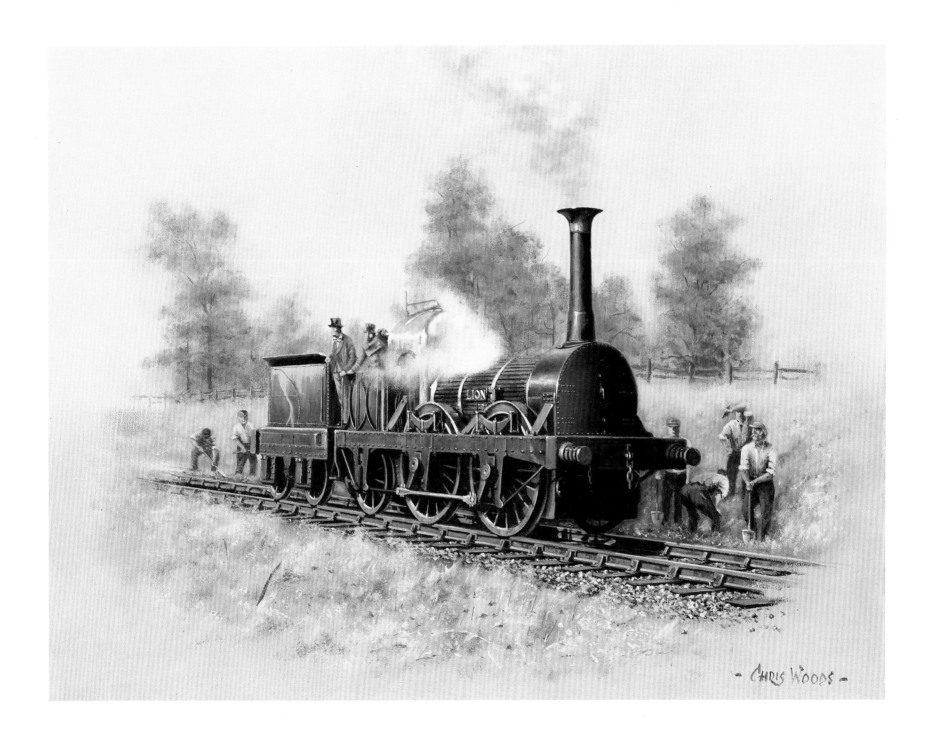

- CHRIS WOODS -

Duty at Folkestone

Ex S.R. Schools class 4-4-0 No. 30926 Repton *preparing to leave for London with a boat train.* Repton *is once more in traffic on the North Yorkshire Moors Railway, where it returned to service in 1990.* 24 x 18 in. 1989.

The line up from Folkestone Harbour Station is just under a mile in length, and for much of the way is at an incline of 1 in 30. During the days of steam this necessitated the employ of three, four, and sometimes even five tank locomotives to lift the heavy boat trains away from the harbour station and up to Folkestone Junction.

There were a bunch of 0-6-0's consisting, in the main, of G.W.R. panniers or Wainwright rebuilds classified as R1's. They were permanently stationed at the junction and were housed in their own shed.

These little engines provided stirling service over the years, performing their menial task well, which for them must have been a somewhat abject and see-saw type of existence.

The boat train, having been hauled up to the junction, would be backed onto by a main line express locomotive which had been rostered to take the train on to Victoria.

I have taken this final manoeuvre as the theme for 'Duty at Folkestone'. The boat train is being backed onto by a Schools class engine, in preparation for its run up to sodium lamp land.

At the time of the painting, No. 30926 *Repton* had not long returned to this country from its rather lengthy and dismal sojourn in the U.S.A., where it formed part of the Steamtown Collection in Vermont. It languished there for some time before going on loan to the Cape Breton Steam Railway in Canada, where it underwent many bizarre modifications to suit the Canadian Railway Regulations. These adaptations included a suitable whistle, a bell and the inevitable cowcatcher, together with the fitting of a huge automatic buckeye coupler in place of its own buffers.

In view of *Repton's* return home to the sympathetic attention of the preservationists of the North Yorkshire Moors Railway, I decided to feature this locomotive in my painting. Way across the tracks in the background the crew of Battle of Britain Light Pacific No. 34085 *501 Squadron* is busy preparing their engine for duty on the Golden Arrow.

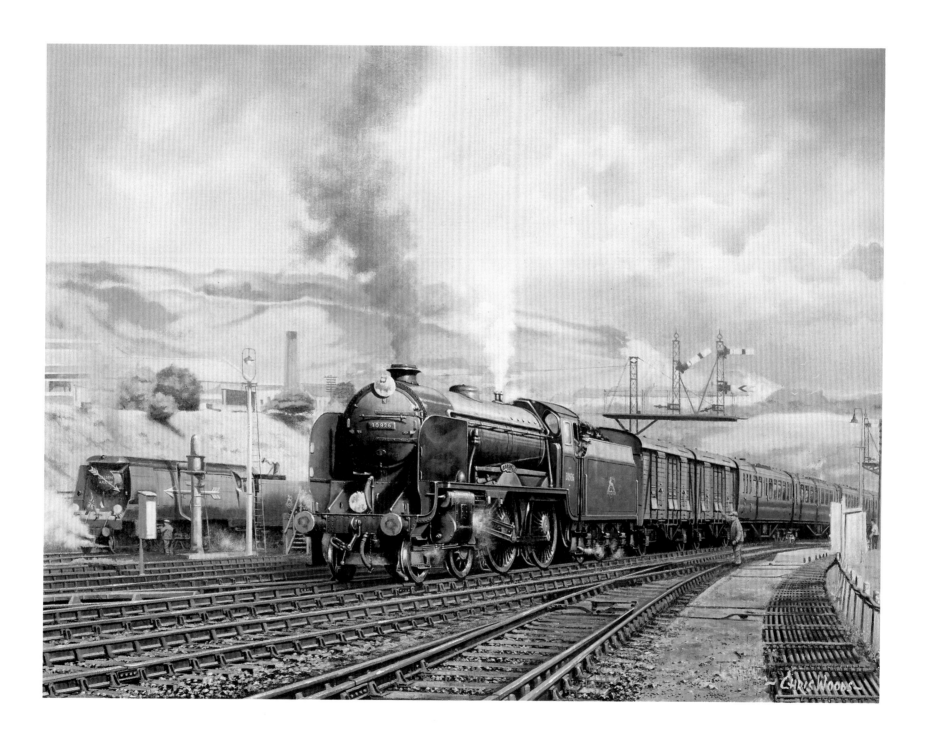

Over the Canal

Ex G.W.R. Hall class 4-6-0 No. 4918 Dartington Hall *leaving Chester with a train for Birmingham, passes a narrowboat as it gently positions itself in the confines of the lock.* 30 x 20 in. 1990.

Friends of ours, David and Bea, had moved to Chester. They had reason to reside there for just a few years only, but during that time I believe they developed an appreciation of the old Roman city.

Margaret and I were holidaying in North Wales, as is our wont, and took the opportunity to motor over to Chester to stay with them for a couple of days.

David volunteered to take us on a guided tour of the city walls. We sheltered beneath large striped golf umbrellas, as it rained quite steadily while we sauntered around, absorbing the charm of the old Tudor buildings as we made our way down the steps, to leave the walls in favour of the busy main street, and coffee.

David was fascinated by the Shropshire Union Canal which ribboned through Chester, punctuated by a series of lock gates. There is a canal basin, where one can obtain supplies, effect repairs, or merely repose. Working alongside the basin was 'Snowy', a grey heavy horse, whose purpose in life was to haul the narrowboats along the towpath. He was an intelligent and somewhat amusing animal, for when he was free from duty, and the time was right, he would set off on his own along the length of the towpath, passing under the railway, and thereby into the park by the lock gates, where he then spent his tea-breaks and lunch hour! He was no fool!

After a while our friends moved back to Hampshire, and Bea asked me to paint 'Over the Canal' for David's birthday, as a reminder of their time spent in the north.

This painting is located just where the railway crosses the Shropshire Union Canal by the lock; a narrowboat has just arrived to wait its turn before sliding down to the basin below. The train passing is bound for Birmingham, whilst the other one, disappearing into the clinging smoke, is arriving from Holyhead, Bangor, and resorts along the coast of North Wales. In days gone by the routes of the Great Western Railway were taken along the metals seen to the right of the painting, whereas those to the left were used by the London Midland & Scottish Railway. However, during the latter years of steam, the importance attached to this paled into insignificance. Incidentally, the grassy area on the right is where 'Snowy' spent his free time.

Those who view this spot today will be immediately aware of one formidable addition of modern conception. A concrete ring road, up on stilts, passes between the trees and the buildings in the background. This ghastly highway splits the old city in two, but in view of the amount of traffic it supports every hour, the evidence of the necessity for its construction, sadly must be conclusive.

For those who are not familiar with Chester, it really is a lovely old place, full of history and interest, including a cathedral built of red sandstone, and Eastgate, which was rebuilt in 1769, is surmounted by a centre clock of ornamental design, supported by filigreed ironwork. The clock commemorates Queen Victoria's Jubilee.

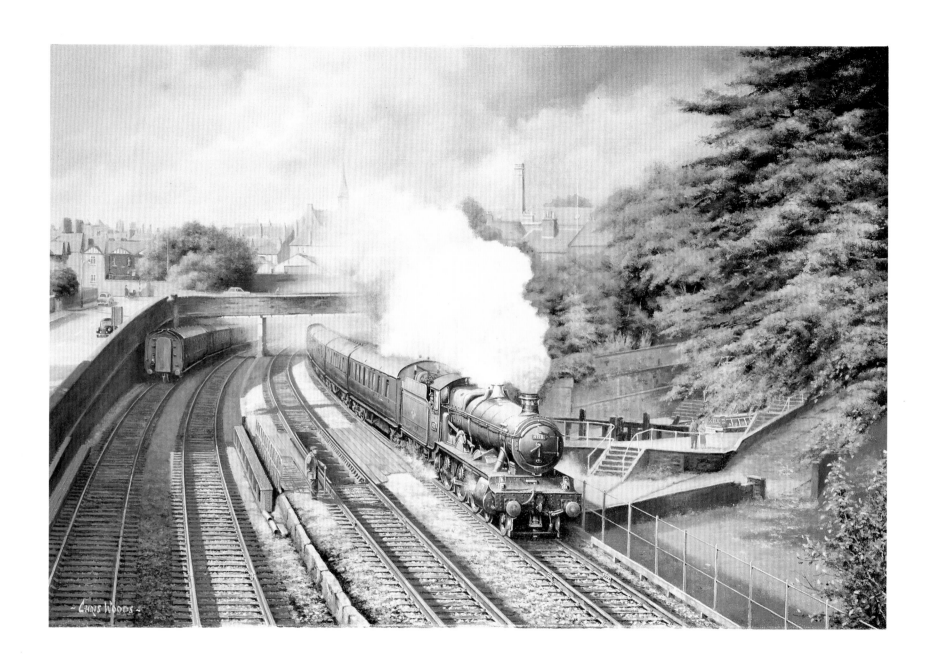

Sunday at Salisbury

Merchant Navy Pacific No. 35027 Port Line *is seen at Salisbury at the head of a train for Exeter. The two permanent way men take a breather in order to view the Sunday service as it passes.* 24 x 20 in. 1984.

It is not *all* hunky-dory in picture-painting land. No matter how arduously one strives to please the public at large with the results of one's labours, inevitably one cannot please all of the people all of the time. Sadly, 'Sunday at Salisbury' is a case in point.

I have always been impressed by fine architecture and, without doubt, the cathedrals and churches in the land provide some of the finest. So when I came upon photographs in a railway magazine of trains at Salisbury with the cathedral as a backdrop, I was keen to produce a painting based on these photographs. My enjoyment would be two-fold: a chance to paint a railway scene, and to include the superlative spire of Salisbury Cathedral.

The finished painting evoked a surprising amount of interest and kind comment at the time, so much so that, on taking advice from people in the fine art trade, it was decided to publish 'Sunday at Salisbury' as a limited edition print.

However, when the print was made available to the public it became the focus of attention of the critics. But curiously the controversy concerned just one particular grievance. "You *cannot* see the cathedral from the railway", I was told – in many cases, strange as it may seem, by Salisbury folk! One driver claimed he had never seen it in all the times he had traversed the line. Then the organisers of the Salisbury Cathedral 'Spire Appeal' declined the offer of a framed print together with ten per cent of the proceeds from the sale of the prints, on the grounds that 'the whole picture was a complete montage, totally imaginary'!

I became despondent, so persistent were these claims that, in desperation the photographs were taken from the magazine and mounted on a board, to be used as evidence in preparation for any future disbelievers of the picture's authenticity. There were. And even then some refused to be convinced when shown the affirmation.

It was bizarre. Like a bad dream. I became even more depressed, and as far as I am concerned, a cloud has hung over the picture ever since. Nevertheless, on a much happier note, my faith has long since been restored on three counts. Firstly, two well-known railway photographers have confirmed that they have taken photographs of the scene on many occasions over the years. Secondly, not everyone thinks ill of the picture as the limited edition prints have continued to sell quite steadily. And thirdly, the original painting was bought by Mr. P. Alderman who was very pleased to add it to his collection of railway art, which pleased me beyond measure.

No. A painter of railway subjects is not a Utopian occupation.

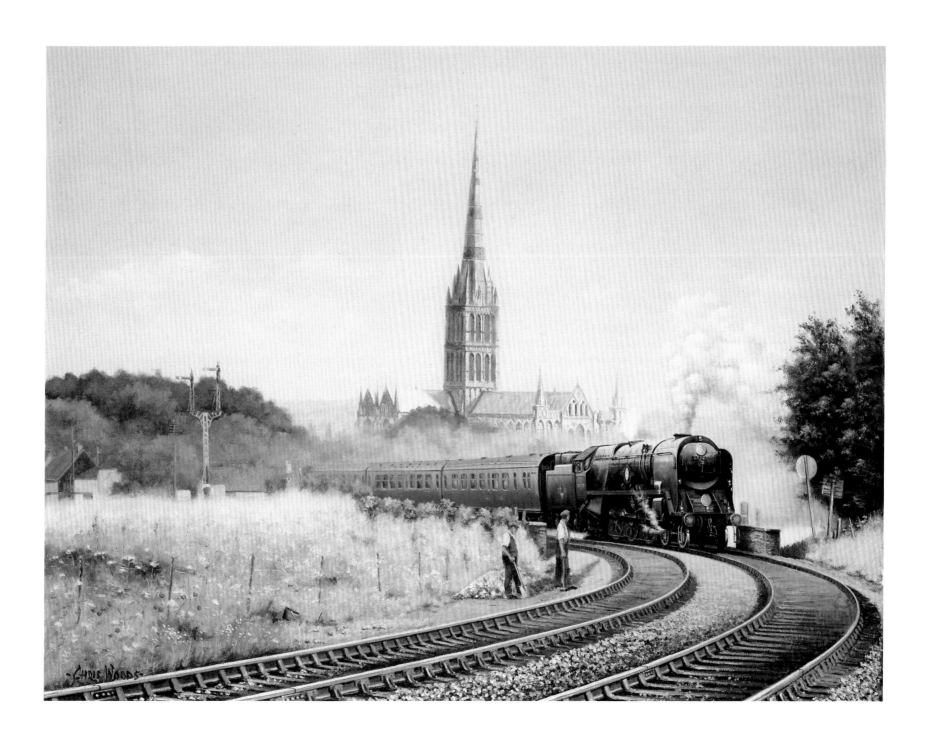

Change at Axminster!

Ex L.S.W.R. Adams 0415 class (Radial) tank No. 30582 simmers patiently in the bay with the branch line train whilst W.C. class 4-6-2 No. 34009 Lyme Regis *slips as she endeavours to get her through train from Brighton to Plymouth under way again during the late 'fifties. 24 x 18 in. 1987.*

I fancy this scene will trigger memories for many folk who enjoyed an escape from dreary routine for a holiday at Lyme Regis in those erstwhile long hot summers so often readily recalled during conversation over a pint at the local.

Axminster was the junction station for the branch line to the seaside resort, and passengers had a delightful seven-mile journey through enchanting Dorset countryside, including the negotiating of Cannington Viaduct, before they arrived at Lyme Regis.

The line, which opened in 1903, consisted of sharp gradients and severe curvatures along its length. This necessitated the utilisation of the Adams (Radial) tank locomotives which, up until 1961, held undisputed influence on the branch, despite the trial of several other engine classes at various times. Nevertheless, the elderly Adams were eventually replaced by the Ivatt 2-6-2 tank which had been designed for the L.M.S. in 1946.

Sadly the branch closed in November 1965 and the scene here today has changed considerably, the signal box, cattle dock siding and yard being removed long since. Following the takeover by the Western Region early in 1963, the main line was downgraded to single track, together with the ex-Southern lines west of Salisbury.

Lyme Regis is still a popular spot for holiday and recreation, though only accessible by road which can, because of its popularity, be quite tiresome for drivers unless they are prudent regarding arrival and departure times!

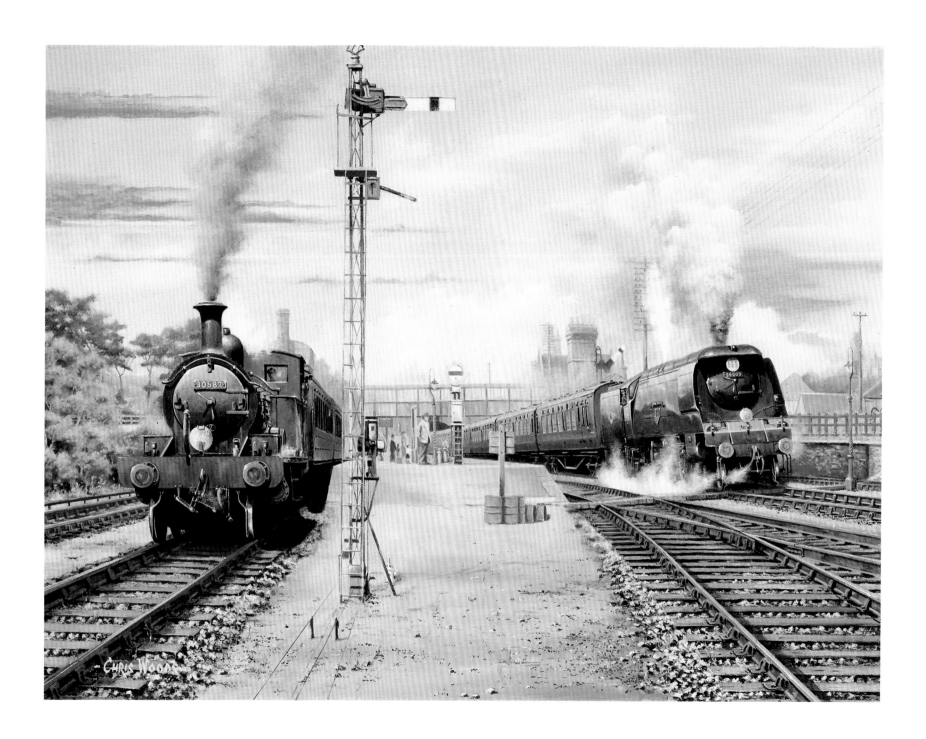

Each a Glimpse

Inter City 125 No. 253 002 is seen here with a Paddington-bound train from the West Country. The farm workers, heavily engaged in conversation, appear to be completely oblivious of the passing flash of modern traction. 24 x 18 in. 1990.

This was my first venture into the world of diesel locomotives, having been tentatively asked if I would be prepared to temporarily abandon the world of steam to paint it. I believe John Hill was pleased, if a little surprised, when I agreed to his request and he proceeded to supply me with copious reference material on the subject with which to indulge myself for the following few weeks or so, before actually embarking on the painting. He left the location entirely to me, but did specifically ask for the train to be painted in its original livery and for it to be on the Western Region in about 1977.

The location I chose was Dainton Bank but as the painting progressed it drifted more towards being merely based on Dainton Bank! I decided to work in the two men having a conversation in the lane. These men actually worked on the farm just across the fields from where I live. The one wearing a white sun hat was the cowman and the old boy, who had actually retired, did odd jobs around the farm, including the plumbing. He was kept gainfully employed as the local gang of 'little treasures' were constantly vandalising the water troughs in the fields by persistently wrenching out the ball cock! Both these characters have now gone – the cowman to a farm in Cornwall and, sadly, the old man died shortly before I finished the painting.

However, a few months later the painting was among others at a local exhibition, and who should walk in but his widow. As she wandered round looking at the paintings she came to 'Each a Glimpse'. Here was a moment of poignance indeed as, with a tear in her eye, she whispered, "Oh, look, my old Fred".

Island Holiday

Adams 02 class 0-4-4T No. 20 Shanklin *trundles its train of vintage wooden-bodied carriages along Ryde Pier bound for Cowes in the late 1950s. BR paddle steamer* Ryde *has just arrived and is ready to disgorge yet another load of excited holidaymakers.* 24 x 18 in. 1987.

A local printing and publishing company asked me if I would paint a series of seven pictures for their in-house calendar. The company had a large contract with British Aerospace and because of this the calendar usually had a distinct aviation bias. However, it was thought that a change would be nice and so decided on a theme of 'Trains Around the Solent'. The resulting calendar proved to be extremely popular as the company received continual requests for extra copies, more so than they had experienced before. 'Island Holiday' formed part of this calendar.

This scene proved to be an evocative one; after all, it represented landfall for thousands of holidaymakers down the years, and where their journeys then began, taking them to the numerous resorts and beauty spots across the Isle of Wight.

In 1939, when I was seven years old, I was on a week's holiday with my mother at Ryde, my father unable to be with us because he had to work. I have never forgotten the whistling milkman on his early-morning round. We were treated each and every morning to his cheerful tune, albeit the same one over and over again – 'South of the Border, Down Mexico Way'!

My Dad was coming over on a paddle steamer to meet up with us for the return journey home. I went with Mum to Ryde Pierhead to await his arrival but all we managed to see were hundreds of evacuee children arriving, each one armed with a case and a gas mask box swinging from the neck by a piece of string. After a long wait my mother was told that the boat we were waiting for had been diverted to Cowes. We had not heard Mr. Chamberlain's historic announcement that war had been declared.

We met up with Dad eventually, who told us his tale of woe. Evidently the boat he had been on was stopped in mid-Solent and boarded by a naval party, as it was feared that the passengers were possibly members of an enemy invasion force. Nevertheless, after identification had been established, the paddle steamer changed course and headed for Cowes.

Evocation indeed!

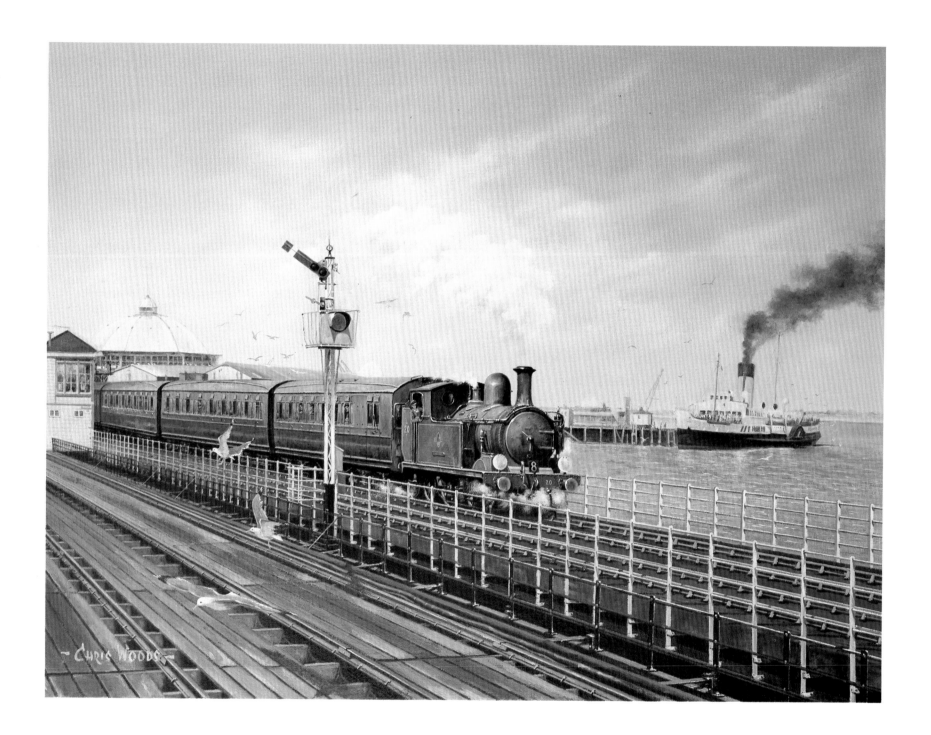

Eclipse of a Star

Ex G.W.R. Star class 4-6-0 No. 4056 Princess Margaret *gently reverses onto No. 7029* Clun Castle *waiting at the head of a train for Plymouth, just as the gas turbine No. 18100 runs through the station in the middle road at Exeter St. David's.* Clun Castle *remains today a fine example of preservation.* 30 x 20 in. 1991.

Was this to be the shape of things to come?

The 4th March, 1952, was a sort of red-letter day. The newfangled British-built gas turbine locomotive set out with an eleven-coach test train on a journey to Plymouth. This powerful locomotive of radical design, No. 18100, built by Metropolitan Vickers Ltd. at their works at Trafford, Manchester, had two drivers in the cab for this test run. Those entrusted with this all important working were Drivers Pither and Wilton.

My client, Mr. Cocking, had the idea for me to paint a scene for this 40th Anniversary occasion, and to locate the action at Exeter St. David's Station. He had been a pupil at Sutton High School, Plymouth, and expressed a wish to be represented in the painting in school uniform. I believe he was motivated to this end on seeing himself in a photograph in a book, watching the arrival of this train at Plymouth North Road. He supplied me with enough information regarding his uniform, including an ancient school cap of a dark and light blue ring design from which to work.

As the scene began to materialise in my mind, I thought it significant to also include some boys from Exeter School. This meant contacting the school concerning their uniform of the period in question. The gentleman to whom I spoke was interested to hear the reason behind my request, and was only too willing to oblige. In fact he could not have been more helpful, sending me photographs, and diagrams of the school badge.

I decided to create a scenario involving the almost nonchalant manoeuvre in No. 1 Platform by a lovely old Star class engine backing onto a Castle class, already standing at the head of a train for Plymouth, in preparation for a spot of double-heading. This tactic obviated the possibility of a delay caused by the Star running light engine ahead of the westbound train.

Onlookers gathered at the end of the platform opposite to watch points, when they were suddenly bewildered by the sight and sound of the outlandish, high-tech black box heading up the middle road. Had the world gone mad?

Ironically, this futuristic example of locomotion proved to be somewhat unreliable, and indeed was outlived by the aged and well-travelled Star, and the old girl was the last of her class to be withdrawn in 1957. She also retained her number on the buffer beam in true Great Western fashion.

Incidentally, I dare say the boys from Exeter School were indulging in a spot of 'absence without leave' or being out of bounds. I'm not sure about young Master Cocking!

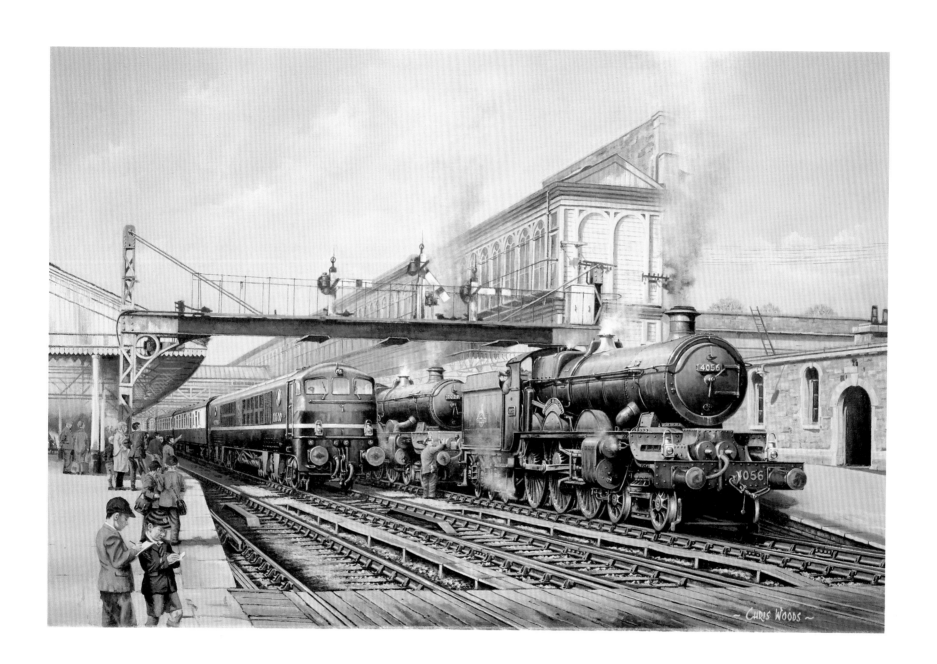

~ Chris Woods ~

Winter Freight

Ex L.S.W.R. T9 4-4-0 'Greyhound' No. 30732 with the local freight, trundles past Droxford signal box on its way to Alton. Shunting and freight haulage was shared by T9, 700 and, latterly, by U classes. 24 x 18 in. 1987.

Winter. This could be my favourite period.

A winter landscape is a sleeping landscape but, at the same time, many unexpected joys can be revealed. A bright, clear, January day may induce one to wander out to seek some of these delights.

A robin, with melancholy lyric, surveys the scene from its perch on a frost-rimed hogweed plant, as the sun, though in shallow trajectory, gives a genial glow of warmth at the lane corner, maybe just enough to dissipate the snow at its edge, and relieve the chill of the frost-bound wayside.

From a laneside look-out post a mistle thrush, pushy as ever, sings its wild roundelay. Two magpies flounce over the hedge of brambles and gorse which is already spitting a few golden sparks, and lapwings swirl across the sky in vast numbers.

In a shaft of amber light one may glimpse a squadron of gnats in a crazy dance, bouncing up and down on their invisible trampoline.

The days are short. All too soon the sun surrenders to the beckoning horizon once more, as an early barn owl floats by as silent as the snow itself. The temperature begins to fall and as the frost returns to sparkle in the premature twilight, the parka is pulled up snugly around the neck as tea signals – along with central heating!

The sun began to go down also on this lovely old railway in 1955, when it was closed to all passengers, together with freight services at Tisted, Privett and West Meon. However, goods trains continued to run north from Fareham to Wickham, Mislingford and Droxford until April 1962, and south with the Farringdon goods which hung on with gutsy persistence until August 1968. The sun had finally set for good on the Meon Valley line.

My painting 'Winter Freight' represents the Fareham to Alton goods at Droxford on one such January day. A conscientious porter has evidently cleared just sufficient snow from the platform for underfoot comfort. The signalman is snug and secure within his domain, with his fire going full blast. There is nothing quite like a good stove to get a sumptuous fug going.

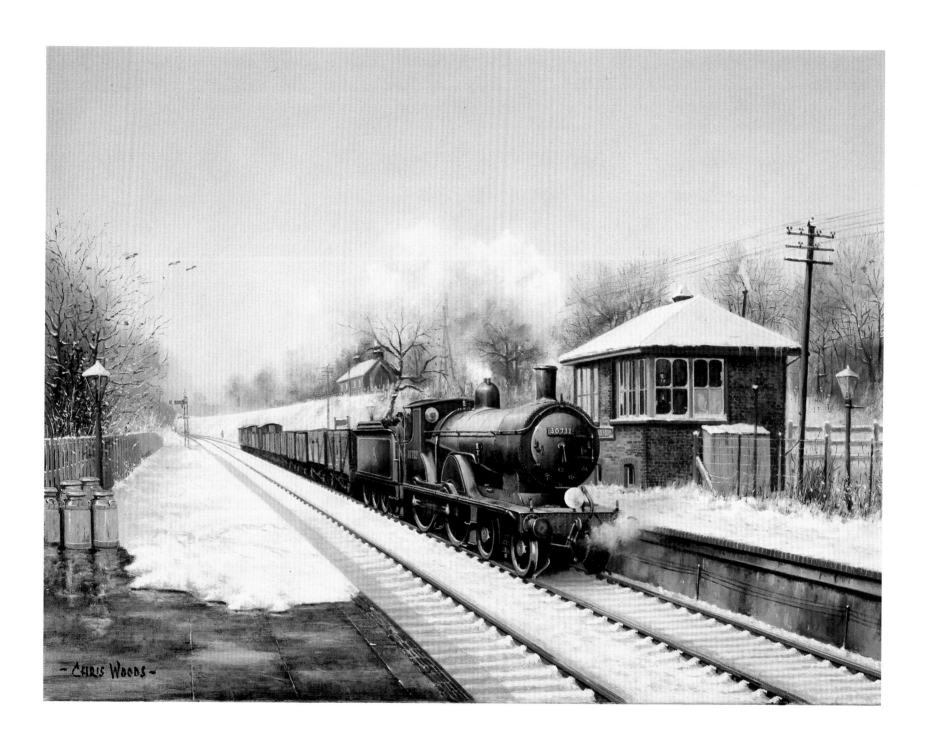

Epilogue

Throughout the pages of this book I have made frequent reference to all the lovely people I have met, and the friends I have been fortunate enough to make, since entering the painting and railway arenas. I cannot emphasise enough the pleasures and uplift I have derived from their company and listening to them unfold their assorted and colourful memories.

With this in mind I leave you, if I may, with a final anecdote which reflects my sentiments indubitably.

When in Wales, Margaret and I frequent a tiny, olde worlde tea shoppe in Criccieth. There, hanging on the wall, among many other curios and delights, is a blue and white plate with an inscription, which reads:

'There Are No Strangers Here,
Only Friends We Haven't Yet Met'

Acknowledgements

Thanks are due to the following who have kindly agreed to their paintings being reproduced in this book:

Mr. P. Alderman

Mr. R . Banks

Mr. & Mrs. P. Brokenshire

The Bulleid Society Ltd.

Mr. J. Cocking

Mr. & Mrs. D. Cowper

Mr. G. A. Dickinson

Mr. G. Evans

Hampshire County Council
 Museums Service

Mr. R. Hardingham

Mr. & Mrs. J. D. Hill

Mr. J. Hodgson

Mr. R. Ince

Mrs. H. Jordan

Mr. & Mrs. D. MacDonald

Mr. W. Millard

Mr. & Mrs. G. Pope

Mr. N. Robson

Mr. P. Smith

Mr. & Mrs. D. S. Swift

Mrs. M. E. Woods

Acknowledgement is also due to:

Felix Rosenstiel's Widow & Son Ltd., who have allowed us to reproduce 'Summer Saturday', published as a fine art print.

The Newcomer's Gallery Ltd., who have allowed us to reproduce 'Along the Camel' and 'Time for Thought', both of which have been published as fine art prints.

Stable Design & Print, who have allowed us to reproduce the original painting 'A Moment at Sherborne', published as a limited edition print.

No discourtesy is intended if, in some cases, no credit is given as to the ownership of a painting. It is simply that during the intervening years I have lost touch with some of the owners and certain paintings have changed hands and so I no longer know where they are. Therefore, the most appropriate thing to do is to thank everyone and hope that you are pleasantly surprised to find your painting within this book.

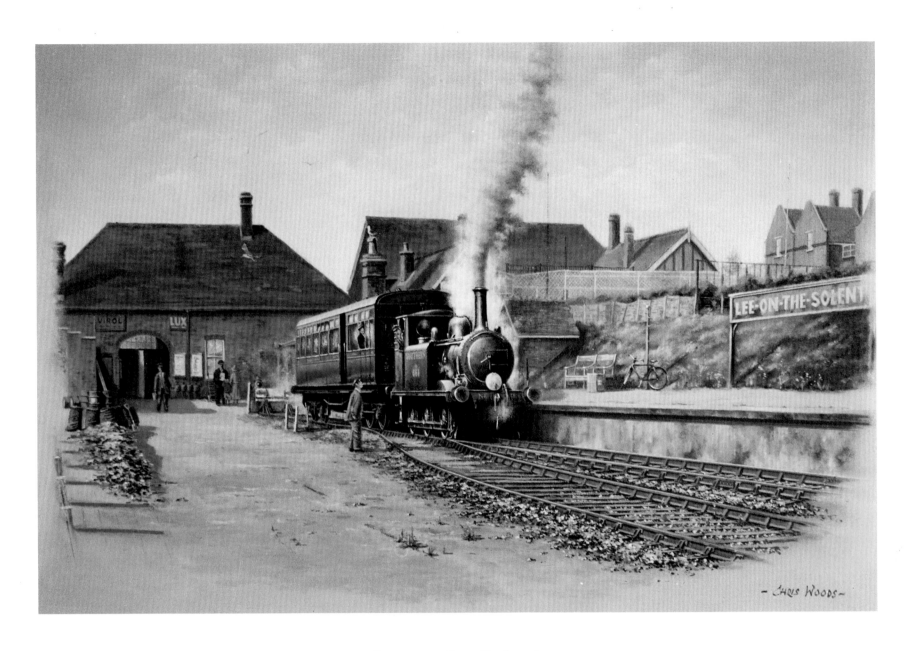

Lee-on-the-Solent

Stroudley 'Terrier' No. B661 appears anxious to leave for Fort Brockhurst in the late 1920s. 30 x 20 in. 1987.